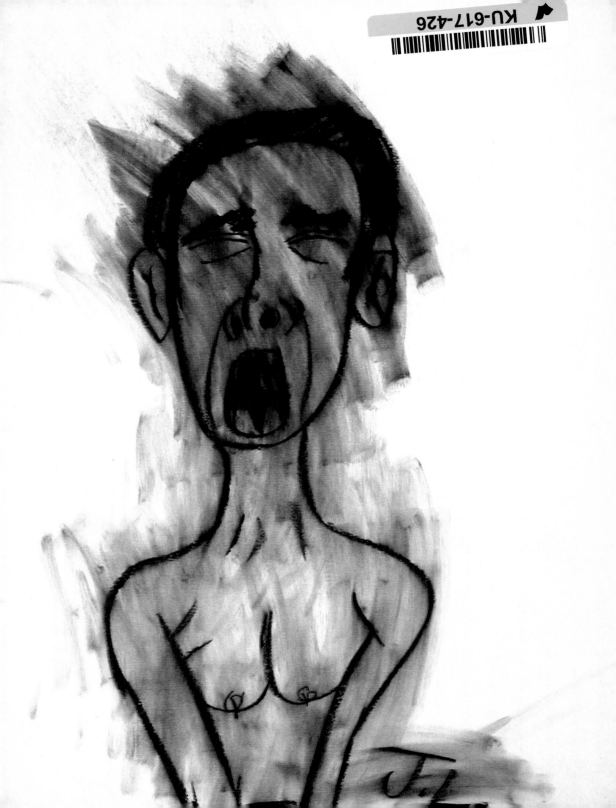

Horre Johann, 1972

Horre Johann liegen auf dem Rücken
und Harall Brigitte darauf liegen
Sepstbefriedigung machen die
zeit Rüdeern Horre Johann
Harall Brigitte in wien...
Praterstrasse, 58, Stige 1. ...
in dem Schlafzimmer dein
Schlafen Dürfen,

how to look at OUTSIDER ART

LYLE REXER

Harry N. Abrams, Inc., Publishers

This book is dedicated to Don Sunseri (1939-2001) artist and founder of Grass Roots Art and Community Effort (G.R.A.C.E.), Hardwick, Vermont.

Acknowledgments

In addition to the institutions, collections, and individuals acknowledged in the photograph credits, the author would like to thank especially the following people:

Frank Maresca, Roger Ricco, Sherry Cavin, Randall Morris, Margaret Bodell, Norman Brosterman, Mickey Cartin, Don Christensen, Creative Growth Art Center, Bruno Decharme, Andrew Edlin, Johann Feilacher (Haus der Kunstler, Gugging), Robert Greenberg, Bonnie Grossman, Marion Harris, Steven Harvey, Tanya Heinrich (American Folk Art Museum), Susan Larsen, Caroline Kerrigan, John Maizels (*Raw Vision*), Robert Provenzano, Carol Putnam (G.R.A.C.E.), Cheryl Rivers, Luise Ross, Jennifer Pinto Safian, Kerry Schuss, Jeff Way.

The author also owes a debt of gratitude to his editor, Deborah Aaronson, and his designer, Brankica Kovrlija. As the poet said, "Patience is a point, tho it displease oft."

Editor: Deborah Aaronson
Designer: Brankica Kovrlija
Production Manager: Jane Searle

Page 1: Jonathan Lerman. Untitled, 2002. Charcoal on paper, 24 x 19".

Page 2: Johann Korec. Untitled, 1992. Watercolor and ink on paper, 8½ x 5¾".

Library of Congress Cataloging-in-Publication Data
Rexer, Lyle.
 How to look at outsider art / Lyle Rexer.
 p. cm.
 Includes bibliographical references and index.
 ISBN 0-8109-9202-7
1. Art brut. 2. Outsider art. I. Title.

N7432.5.A78R475 2005
709'.04'07—dc22
 2004023441

Printed and bound in Singapore
10 9 8 7 6 5 4 3 2 1

HARRY N. ABRAMS, INC.
100 Fifth Avenue
New York, N.Y. 10011
www.abramsbooks.com

Abrams is a subsidiary of
LA MARTINIÈRE

CONTENTS

INTRODUCTION

"Here are marvelous things made without permission."[1] PETER SCHJELDAHL

"Outsider art" has become a catchall phrase for everything that is ostensibly raw, untutored, and irrational in art. From being the hobby of a few collectors, it has ascended to its own status within the art world, with its own canon of classic artists and works, key dealers, museum exhibitions, an annual dealers' fair in New York, and even its own auction category at Christie's. It is hoarded by ambitious collectors around the world and is in the process of being integrated into the contemporary-art mainstream, finding a place on museum and gallery walls next to Warhols, de Koonings, and Pollocks.

In spite of this popularity, most people interested in art and even many aficionados of outsider art cannot say precisely what outsider art is or distinguish it from its companion genres, "self-taught" art and folk art. And when it comes to judging new or unfamiliar work, most people cannot evaluate what they see. They are often intimidated into accepting opinions they may not agree with, or because the world of outsider art seems to lack aesthetic criteria or guidelines, they are reduced to defending their tastes with the phrase, "Well, I just like it." That may be sufficient when the cost of an acquisition is low and whims can be painlessly satisfied, but as outsider and self-taught works by the best-known artists increasingly command upward of six-figure investments, instinct and taste need the support of critical judgment, at least insofar as this is possible without losing the thrill of discovery.

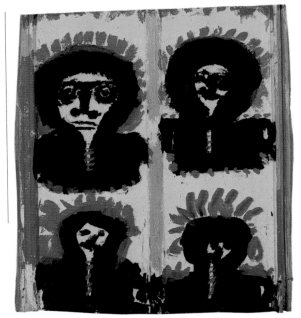

I am well aware of these dilemmas because I have experienced them myself. When I first began to pay attention to outsider art in the 1980s, I knew only the few names of artists who were already legendary—the schizophrenic Swiss graphic artist Adolf Wölfli (1864–1930), the self-taught French customs agent Henri Rousseau (1845–1910), and the mad Englishman Richard Dadd (1817–1886). I had no clear idea how these artists might be related or even if they should be mentioned together. The entire field seemed to me to reside somewhere between the folk art of Grandma Moses and the mysticism of William Blake. Never mind that Moses's world has its dark and dangerous places, far different from the popular image of her work, or that Blake's "vision" is often pedantically coherent. Outsider art certainly didn't seem to fit into the history of Western art that I knew, which stretched (sometimes thinly) from the sculpture of ancient Greece to the broken-plate paintings of Julian Schnabel (b. 1951). I had no idea that the field is actually many "fields," some of its creations arising from communities of shared practice and understanding, some highly idiosyncratic. Like-

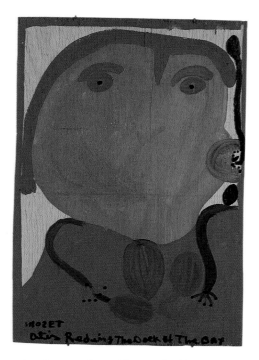

Mose Tolliver
Otis Redding, the Dock of the Bay, 1987-88
Enamel on plywood, 23¼ x 15¾"
The African-American experience 2: Historical and cultural figures inspire Tolliver.

wise, the art of outsiders and self-taught artists embodies many different intentions, from religious proselytizing to the indulging of sexually aggressive fantasies. Some of this art actively engages the outside world; some of it retreats deliberately from that world or attempts to reconstitute it wholly.

Over time, I began to make some of these distinctions and to approach different works on their own terms, recognizing that, for instance, Mary T. Smith (1904–1995), attempts something different from Mose Tolliver (b. ca. 1919), although both are artistically untutored African Americans with southern roots, fully aware of their own artistic ambitions. I was at least confident enough to make choices based on what I did and did not respond to. I even wrote a book on the subject with two of the leading dealers in the field.[2]

And then I had a revelation.

In the early 1990s, a friend called me from an antique shop in upstate New York and asked me if I could identify a drawing that he thought was

by Martin Ramirez, the self-taught Mexican-born artist who spent several decades of his life in a mental institution in California. The renown of Ramirez, who died in 1963, had risen throughout the 1980s, and he was regarded as a paragon among outsider artists. I drove a hundred miles just to see it. We have all read stories about people finding a Rembrandt drawing in their attic or a Picasso painting in the trash. This was as close as I'll probably ever come to such a discovery. I walked into the shop and saw the four-foot-tall drawing of a deer, Ramirez's signature image, probably based on his memory of Mexico but transformed into a stark and haunting symbol of animal powers. Not only did I understand immediately why the artist's reputation was so high, but I also saw that such a work spoke with the same visual authority as work by the best artists I knew. This "outsider" work shared something essential with great mainstream, or "insider," work.

Martin Ramirez
Untitled, ca. 1950s
Crayon and graphite
on paper, 51 x 23½"
At the center of vision:
The deer, the cowboy,
and the saint have iconic
significance for Ramirez,
who stages them with
elaborate framing.

It issued out of deep necessity and embodied the full formal capacities of a distinctive visual imagination. Uniting memory and belief, it recorded how one intelligence had encountered the world. It struck me then that the best outsider art could open doors to an understanding of art as a whole, even contemporary art with very different, not to say opposed, intentions. It could also renew our appreciation for so much we thought we knew too well, whether it was works by Paul Klee, Andy Warhol, or the Sienese mural painters of the early Renaissance.

The more I discuss outsider art in this book, then, the closer I hope to come to the inside of art, to the ways art signifies, communicates, and inhabits our lives. Given the unconventional nature of this art, I am tempted to issue a label that says, "Warning: Outsider art can be aggressive, explicit, and dangerous to your concept of beauty." Of course, much art done by modern insiders could carry the same label. Outsider art can also be delicate, enchanting, and intellectually complex. This book is an attempt to explore all these aspects, to specify what the works may have in common, and to understand how we have come to appreciate them.

It is also an attempt to show what certain works do not have in common. In art galleries and in most exhibitions of self-taught and outsider art, one is likely to see everything from early American advertising signs and Native American artifacts to Haitian Voudou flags, religious art from the South, and works by people in severe mental distress. It does not take much experience with art to realize that the differences are far greater than the commonalities or, at least, more significant. As discussed later, many of these objects do share some common ground, but putting them into a very large suitcase called "self-taught" or "outsider" certainly makes them harder to appreciate. The diversity of contemporary art can help us unpack the suitcase and see how varied its contents really are. In the end, the notion of "outsider" may be like the metaphor of a ladder used by the philosopher Ludwig Wittgenstein, something we climb up only to kick away when we reach the top, and keep climbing.

1

Art without Artists

Inside or Outside?

What do the following artists have in common: Rembrandt van Rijn, Gustave Courbet, Vincent van Gogh, Käthe Kollwitz, and Pablo Picasso? Answer: They are now recognized as among the greatest artists of the Western tradition, and they all produced art that has been called primitive, gauche, ugly, and strange. They have all been considered at one time or another outside the mainstream of taste, beauty, and the art market because they attempted to introduce into art life experiences that the then-current styles and audience attitudes excluded. And they did so, inevitably, in ways that seemed outlandish, offensive, and unacceptable.

"Outsider art" is a loaded term, one that mixes aesthetic judgments with social, economic, psychological, and even political designations. It can be applied to many kinds of art produced by wildly different sorts of artists. And like so many terms in contemporary art, it is also hotly contested, at least as much as "beauty," "truth," "nature," and other terms long considered the foundations of art appreciation. Unlike such terms, however, "outsider" does not have a long history of usage. It was unofficially coined only in 1972, when the art historian Roger Cardinal, seeking a more flexible and evocative description of certain forms of extreme, untutored art, used the term as the title of his now famous text. He was dealing primarily with the category of *art brut* (raw art), coined by French critics and the artist Jean Dubuffet (1901–1985) to describe art made by people clinically diagnosed as insane, as well as art made by visionaries and eccentrics at the fringes of society. Yet by broadening the category slightly in his translation of *art brut*, Cardinal opened the door to a crowd of interpretations and candidates. "Art brut is a teeming archipelago rather than a continent crossed by

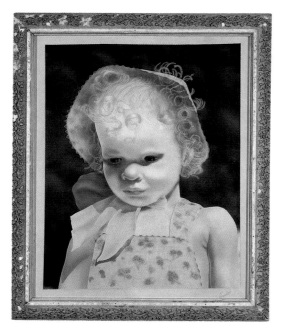

Morton Bartlett (1909-92)
Untitled, early 1960s
Gelatin silver print with
airbrush pigment, 20 x 16"
Beyond the snapshot:
With airbrush and enlarger,
Bartlett transforms an
almost ordinary photo of a
young girl into an emotion-
ally complicated portrait.

disputed borders," he wrote. "The only connection between each 'island of
sensibility' is that they are all distinct from the cultural mainland. And the
only assumption of 'likeness' . . . would be the common likeness in the
works of a single artist."[3]

"Outsider art" is not an art movement recognized as distinct by its prac-
titioners or even by scrupulous critics. So it stands apart from the jostling
crowd of twentieth-century "isms"—Futurism, Constructivism, Cubism,
Fauvism, Surrealism, and Dadaism, to name just a few. However vague the
borders they specify, all these names roughly indicate shared approaches,
assumptions, styles, or attitudes to tradition. They are all implicitly histori-
cal in orientation, ways of marking off some group of artworks and artists
from all other art past and present. In many cases the names are the cre-
ations of artists themselves, or at least accepted by some of them, and not
exclusively the pipe dreams of scholars, historians, and art dealers. But
"outsider art" *is* the creation of historians, critics, collectors, and the like,
indeed a creation of everyone *but* the artists. And unlike the isms, it does

not refer to the art but to the status of the people who make it. Its "members" share almost no assumptions about art and are not connected, in terms of practice, to an art world of dealers and critics. Nor do they necessarily have in common life situations, mental states, attitudes toward the past, or intentions toward an audience—or even the awareness that they are doing something called "making art." To give an idea of how radically the works in this category may differ from each other, we need only to compare two artists who are often classed as "outsiders."

Drossos Skyllas (1912–1973) was a self-taught painter of Greek origin, but he was far from ignorant of traditional Western art or art history, nor was he a social outsider. He started out in the tobacco business and then was supported by his wife as he actively sought a reputation for himself as an artist. Admiring the great devotional works of Christian art, he approached them as models whose beauty he sought to equal. He perfected what he

Drossos Skyllas
Lola D. Skyllas and Her Mother, 1955-60
Oil on canvas, 48 x 33"
Like many other self-taught artists, Skyllas is a slave to visual convention—but incapable of following the rules.

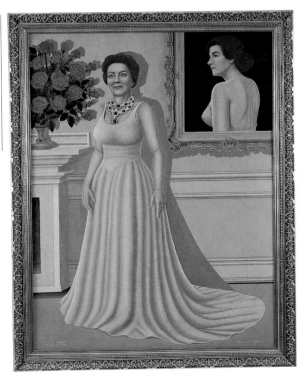

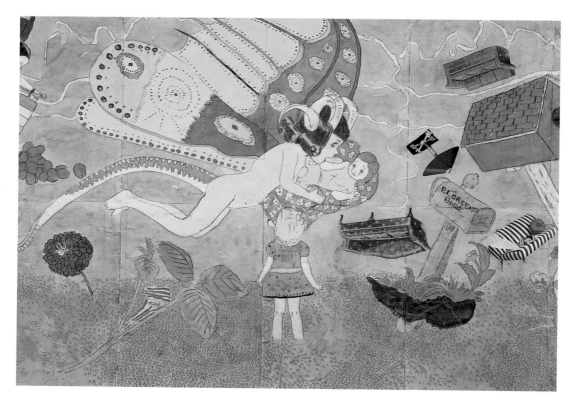

Henry Darger
Untitled (At Jennie Richee), detail, ca. 1950–60
Watercolor, collage, and ink on paper, 23 x 107¼"
Although Darger is called the classic outsider, hermetic and private, his work is presented as an epic narrative, on a grand and self-consciously public scale, as if he imagined an audience of readers.

imagined were the realistic techniques of the past and embodied his idea of aesthetic perfection in precise and unblemished renderings of pastoral scenes and nudes. Skyllas should not be regarded as an outsider in any sense except his lack of financial and critical success. In his very attempt to mimic traditional art, however, he veered away from convention, traveling beyond fidelity to his models into a conceptual realm of antiseptic sexuality, with buxom fantasy women who look like a cross between Varga's pin-up girls and Photorealist kitsch. Still, the connection to his art-historical models is always evident, and we see all of Western art through his distorting glass of wish fulfillment.

On the other end of the spectrum is Henry Darger (1892–1973). Solitary, hermetic, the Chicago native lived alone and composed a fifteen-volume epic, *The Story of the Vivian Girls in What Is Known as the Realms of*

the Unreal of the Glandico-Abbiennian War Storm, Caused by the Child Slave Rebellion. Perhaps before he began writing the narrative, Darger created a series of collage watercolor drawings on the same theme, which may have served as the inspiration for the text. He worked by altering cartoon elements that he traced from a variety of sources. His work has no obvious relation to the art of the past or to any fine-art tradition. Formally, its strongest influence is probably the comics page of the daily newspaper. Most important, Darger's visual narrative was private; he almost certainly never intended it to be seen by anyone else—except perhaps God. Certainly he never volunteered to show or discuss it. Where Drossos Skyllas was a perfectionist, completing only thirty-five paintings in his lifetime, Darger was impassioned, hasty, and prolific. Where Skyllas created works of art for public sale, Darger created a violent vision in communion with himself. Where Skyllas was an artist communicating with a tradition, Darger, who could barely draw but displayed an inspired gift for graphic design, was a man arguing with an absent deity. Yet both are often included in the same collections and the same art books. Should Skyllas be coupled with Darger at all?

To complicate matters further, many artists are mistakenly classed as outsiders because they seem to display an untutored, crude, or "primitive" style, when they are in fact working in traditions unfamiliar to Western eyes. The Haitian artist Pierrot Barra (1942–1999) is a good example. His sequined constructions incorporate a remarkable array of discarded materials, from toys and crockery to tinsel and lace. Removed from their cultural context and plunked down among sculptures by Henry Moore or Rodin, they appear wild, "primitive," and raw. But the coherence and meaning of Barra's work arise directly from the imagery of Haitian Voudou, and his method of bricolage, or assemblage, springs from a practice of material recycling originating in West Africa. As the eminent art historian Robert Farris Thompson has pointed out, the same ceremonial and technical roots of artistic practice can be traced in the works of many African American artists.[4] It is more

accurate to call this work contemporary folk art—art based in certain transmitted community values and art practices and largely intelligible to a specific audience, although with a strongly individualistic and malleable attitude to conventions of expression. Haitian art is a cautionary example because it is regularly exhibited with outsider art in spite of its extensive history. There are several distinct "schools" of Haitian painting, with recognized masters, as well as shared imagery and a developed art market in and beyond Haiti. There is even a distinct class of art created primarily for sale to tourists, with its own themes and standardized treatments.

The usual way art historians have of gaining perspective on a phenomenon with a vague outline is to draw up a sort of "family tree" of the art forms that seem to typify it—to pin down Impressionism, for instance, by examining the visual styles and assumptions that seemed to lead up to it and the similarities among works that might generally be accepted under the same heading. But with outsider art, the historian is stymied and the critic disarmed. It is impossible to draw such family trees. There are no common styles or forms to be traced "leading up to" outsider art, and no obvious visual characteristics to serve as a measuring stick of the category. Indeed, we realize we are sketching not the history of some actual phenomenon or conscious movement but instead the history of an idea, in this case, an idea about all the things that insider art is not. True outsider artists are who they are, unaffiliated and idiosyncratic. Their art is what it is, with few references to other art and often little or no sense of an artistic past or heritage. Outsider art tends to be all present tense and to reinvent the wheel in terms of visual forms.

We use the words "often" and "tends" because outsiders are not all self-taught. Nevertheless, the history of the idea of outsider art is useful. By looking briefly at what trained artists, critics, and collectors have made of such work (and by looking at some works by early outsiders), we can begin to see how we might narrow down the category, or at least understand what has attracted audiences to the work for more than a century.

One thing to keep firmly in mind is that all the words we use to categorize and describe art are part and parcel of the time in which we use them. Their meanings change, owing to a host of factors, and if we want to make judgments about the art, we have to try to be clear about what we mean. "Beauty" is one such word. Who at present can agree on its contours? Many critics shy away from using it altogether. Even the idea of "art" as the expression of a single maker's vision of his or her individual experience of reality is not only controversial, but it is also a recent development. In the Western world before the Renaissance, the concept of art per se was very restricted. It was diffused among particular fields of activity—stone carving, painting, glassmaking, and silversmithing. In ancient Greece, "art" excluded most of the visual arts. In any case, the artist's primary responsibility was not to his or her individual view of things but to something or someone beyond, whether to God, the gods, a patron, the church, the nobility, or tradition itself, upheld by an existing social order. If there was no "art" before this period, we can scarcely say there was outsider art, or outsider artists. Outside what? This also begs the question of whether there could have been outsider art in premodern China, for instance, with traditions of painting and sculpture more or less continuous for two thousand years.

Outsider Art in Europe

Since the advent of secular art in the West in the 1400s, there have certainly been eccentrics—artists who by choice or compulsion deviated significantly from the practices of their contemporaries. In most cases, those we know about were part of the art milieu of their day. The very fact that they were known and sometimes shunned for their unorthodoxy is a sign that notions of individuality and originality were becoming important in the judgment of works of art. In other words, as art became secular and increasingly bound up with its historical time, traditions and rules became entwined and often embattled with ideas of change, novelty, idiosyncrasy, and innovation. And with the growth of a private market for art, there arose an "art world"

to be outside of. A few of the artists who perhaps qualify as early out-
siders—that is, outside the mainstream—are well known: William Blake
(1757–1827) and his friend Henry Fuseli (1741–1825), both of whom
chose nightmarish or visionary subjects and unconventional treatments,
went largely unappreciated in their time and struggled against the artistic
norms of the day. Blake was an astute and passionate art critic, and he
challenged preeminent mainstream painters such as Sir Joshua Reynolds
(1723–1792) with acuity and force. Were these artists really outsiders or
just on the outs?

Richard Dadd was a fairly skillful academically trained artist until the
onset of schizophrenia heightened his stylistic idiosyncrasies, not to men-
tion spurred him to murder his father. Giuseppe Arcimboldo (1527–1593),
on the other hand, courted fame and fortune at the Austrian court by
deliberately pushing an eccentric idea to its limit. Technically speaking, he
painted still lifes, but his curious pictures involved the assembling of veg-
etables and objects into the forms of human faces and other figures. Oddly,
he anticipates the work of the outsider Pascal Maisonneuve (1863–1934),
who combined shells and stones into illusionistic faces. The printmaker
Hercules Seghers (1589–1638?), a contemporary of Rembrandt, mastered a
nervous, wormlike style and married it with colored inks and even colored
papers and cloth to achieve effects that still are not fully understood by
scholars. Seghers was secretive about his work and hired no assistants. His
art did not achieve even modest attention at the time. Today he is regarded
as one of Western art's greatest printmakers. Was he an outsider or simply
ahead of his time?

By the end of the nineteenth century, we can chart the rise of modern sec-
ular art by a growing awareness of a division between insiders and outsiders.
In fact, it was certain insider modern artists who, for their own reasons,
found it necessary and advantageous to bring the category of outsider art
into being. By the middle of the nineteenth century, as ideas about history
and society were undergoing profound shifts, many artists conceived of their

practice as opposed to traditional norms and forms and as pointing the way toward possibilities not yet born. In short, they began to think of themselves as an avant-garde. They judged art and authenticated their own practices according to increasingly personal, nontraditional terms. As the painter Gustave Courbet wrote, "When I am dead, they will have to say of me: He never belonged to any school, to any church, to any institution, to any academy, above all not to any regime, unless it were the regime of liberty."[5] In Europe, new art became synonymous with opposition to the status quo. The very name of the famous Salon des Refusés of 1863, the group of artists whose work was excluded from the official Salon exhibition, announced a self-conscious break with tradition, not least of all with the entire tradition of officially sanctioned artistic display. Many of the figures we now regard as precursors of modern literary and visual art—poets Charles Baudelaire (1821–1867) and Arthur Rimbaud (1854–1891) and artists Édouard Manet (1832–1883), Vincent van Gogh (1853–1890), Paul Gauguin (1848–1903), and Paul Cézanne (1839–1906), to name just a few—either actively cultivated a place on the fringe or were forced there by a mainstream art world that condemned their stylistic practices and their subjects.

At the same time, many of these artists took inspiration from folk art or so-called primitive art, which would not have been defined by its makers as "art" at all. In terms of visual form, artists such as Pablo Picasso (1881–1973) and Constantin Brancusi (1876–1957) were deeply influenced by African objects. Others were influenced by artworks from ancient Mexico, India, and the Greek Islands.

For many artists at the beginning of the twentieth century, society—with its materialist values and putative lack of spiritual authenticity—became the fundamental problem art must seek to address with a radically different vision that would be unbound by propriety and convention and originate not in society but in private, inner experience. Whether in Italy, France, Germany, or Russia, no one, it seemed, wished to be aligned with the center, and anything that contravened middle-class values or academic canons

of taste, respectability, beauty, and process could be deployed to alter the sensibility of viewers, in the pursuit of a "new and unexpected reality," as the Surrealist artist Max Ernst (1891–1976) put it.[6]

If by that time the outsider artist hadn't existed, it would have been necessary for insiders to invent one, as a kind of standard-bearer. In effect, insider artists did just that. His name was Henri Rousseau, a customs agent and self-taught painter of moody, dreamlike scenes, who practiced a flat, colorful, and detailed art. When the avant-garde playwright Alfred Jarry, one of Rousseau's first supporters, saw his work, he declared it the antidote to everything conventional, accepted, refined, and sophisticated. Even though the painter himself was indebted to the very values his champions attacked, Le Douanier Rousseau, as he was called, came to be appreciated by members of both the Cubist and Surrealist movements as an artist intimately in touch with an internal wellspring of images, unfettered by cultural conditioning and uncorrupted by historical self-consciousness or art-world sophistication.

Rousseau was the first outsider to be adopted by insiders, and he was far from the last. In the late 1940s, Jean Dubuffet, a conventionally trained artist, became convinced that Western art had cut itself off from its psychic and spiritual roots by indulging in mere formal experimentation. He found the antidote in a type of art that had been gradually coming into public view as a result of the growth of psychiatry—work by the mentally ill and the institutionalized. He coined a term to identify this art, the term still most commonly used in Europe—*art brut*, or "raw art." It was a banner he himself would sail under as an artist. Indeed, Dubuffet appears to have appropriated much outsider imagery almost wholesale into his own art without acknowledging it. He wrote: "We understand by this term [*art brut*] works produced by persons unscathed by artistic culture. . . . We are witness here to a completely pure artistic operation, raw, *brut*, and entirely reinvented in all of its phases solely by means of the artists' own impulses."[7]

Jean Dubuffet
Pleurs de barbe, [Beard's Tears], 1959, Ink and collage on paper, 20⅛ x 13⅜"
Champion and pillager: Outsiders provided Dubuffet with both a cause and an inexhaustible source of material for his own art.

We do not need to belabor the paradoxes of such a statement, the most glaring being its ultimate intention: to introduce these works to the very world of highbrow culture Dubuffet purports to abhor. At the very least, we can ask whether any work with the capacity to communicate can be "unscathed" by culture, or whether it can issue solely from an artist's "impulses," as if these were neatly distinct from the artist's mind and memory.

The work of these psychological outsiders had come to Dubuffet's attention through collections gathered by two important psychiatrists, Dr. Leo Navratil in Austria and Dr. Hans Prinzhorn in Switzerland. Prinzhorn's collection and his book *Bildnerei der Geisteskranken* (*Artistry of the Mentally Ill*, 1922) influenced Dubuffet in a life-changing way. The two physicians' interests lay primarily in disease states, especially schizophrenia, as revealed through art. In their minds, such work stood largely beyond the borders of aesthetic consideration. Yet they were so struck by its forms that they could

not help speculating on the broader domain of human creativity this art illuminated. Prinzhorn wrote: "As groundwater seeps to the surface and flows toward the stream in many rivulets, many expressive impulses run in many creative paths into the great stream of art. . . . There are many springs which finally transcend all life."[8]

Prinzhorn gathered and exhibited the first significant collection of out-sider works, more than five thousand paintings, drawings, and objects, and his book exerted a tremendous influence, not only on Dubuffet but also on the Surrealist writer André Breton (1896–1966) and artists Max Ernst, Alfred Kubin (1877–1959), Paul Klee (1879–1940), and, much later, the Pop artists Richard Lindner (1901–1978), Peter Max (b. 1937), and Peter Saul (b. 1934) to name just a few. Following Prinzhorn's lead, Dubuffet gathered his own collection of outsider work, which became the basis for the world's premier museum of such art, the *Collection de l'Art Brut*, in Lausanne, Switzerland. In 1981 Navratil founded the now famous Haus der Künstler (Artists' House) on the grounds of the Maria Gugging Psychiatric Clinic outside Vienna. The clinic today actively promotes the work of its resident

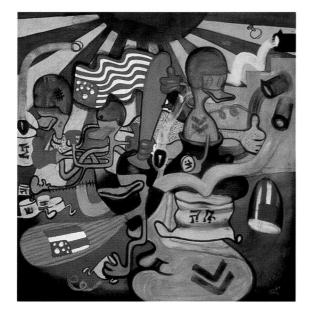

Peter Saul
Americans vs. Japanese,
1964, Oil on canvas, 63 x 59"
Demotic art: The cartoonish
Pop art of Saul and others
opened doors of appreciation
for outsiders such as Darger.

artists, although many of its most important founding artists are quite old or have died.

In essence, according to critic Hal Foster, European insiders saw three things in outsider art, particularly the art of the insane: the uncorrupted origins of expression, spiritual vision, and anticultural transgression.[9] These features suited insider needs, theories, and agendas, but they had little if anything to do with the conditions or intentions of most of the artists actually making the works.

Outsider Art in the United States

Outsider art had a far more complicated reception in the United States, one bound up less with aesthetics and philosophy and more with the politics of national identity and acceptance (or rejection) of urban modernity. This is too complex a story to tell in detail here, but its high points reveal how the boundaries of insider and outsider shift depending on who is affixing the labels. By the end of the nineteenth century, American art had developed from itinerant commercial practice to schooled orthodoxy and had largely adopted European academicism as its broad standard. But Europe also gave American artists contact with a dawning artistic modernity and the permission—for those willing to accept it—to innovate. Some artists, such as James MacNeill Whistler (1834–1903), did so in terms learned overseas, mostly in Paris and London. But for many American artists, eccentricity substituted for innovation. They simply did things their own way and ignored or deliberately distorted their models. The bizarre finishes on the paintings of Albert Pinkham Ryder (1847–1917), the home-grown Impressionism of Edward Hopper (1882–1967), the aggressive regionalism (which was not truly local but idealized) of Thomas Hart Benton (1889–1975), the provocative sexuality of Louis Eilshemius (1864–1941), even the mythic imagery of Jackson Pollock (1912–1956) all express a deep distrust of other artists' ways of doing things and an impulse not to be beholden to any contemporary models or direct precursors.

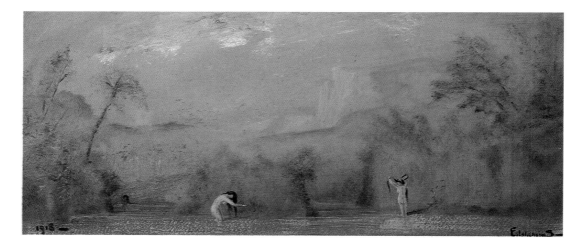

Louis Eilshemius
Untitled (Landscape
with Bather), 1918,
Oil on canvas, 11¹¹⁄₁₆ x 25"
Defying categories: In his
career, Eilshemius painted
as an Impressionist, a mod-
ernist in the vein of Balthus,
and a visionary allegorist,
as shown in this image.

This eccentric modernism dovetailed in some significant ways with a growing sense of both national identity and populist political sentiment. What did it mean to be American and modern and an artist, especially in a country that did not seem to care about art at all? One thing it could mean by the beginning of the 1930s was eschewing sophistication and embracing everyday reality and unclouded sentiment. Before the end of its first decade, the Museum of Modern Art mounted a major exhibition devoted to self-taught painters from both sides of the ocean. "Masters of Popular Painting" (1938) announced that these largely unschooled, mostly working-class "hobby painters," who had nothing to do with each other, formed no "school," represented no isms, and usually worked in conservative representational styles, were not only worthy of display and collection but were somehow "modern." The third in a series of the museum's epochal early exhibitions, following "Cubism and Abstract Art" (1936) and "Fantastic Art, Dada, Surrealism" (1936), it was soon followed by the exhibition "Contemporary Unknown American Painters" (1939), organized by the modern-art dealer Sidney Janis. As director Alfred Barr, Jr., put it in the catalogue for "Masters," "The purpose of the exhibition is to show, without apology or condescension, the paintings of some of these individuals, not as folk art, but as the work of painters of marked talent and consistently distinct

personality."[10] Importantly, the 1938 exhibition included both Hispanics and African Americans, ethnic groups almost invisible in the art world of the day. Missing, however, were true outsiders—the mentally compromised, hospitalized, or incarcerated. Given the museum's subsequent history as a bastion of art-world orthodoxy, it is hard to believe that MoMA once championed self-taught art so vigorously. It not only mounted the key group shows but also presented the first one-person exhibition ever devoted to an African-American artist by a major museum, the sculptor William Edmonson (ca. 1870–1951), and the artist was self-taught.

The idea of a homegrown, unrefined, representational art also resonated with a Depression-era socialism and its penchant—already so familiar to Russians after the rise of Stalin—for anecdotal realism, for pictures that told stories about ordinary people. It was precisely this basic conservatism and recourse to conventional forms that American abstract artists (many of whom were European immigrants) successfully overturned after World War II. They fought their battles in the name of artistic freedom and the deeper truths of individual expression. Regional, eccentric, and self-taught artists provided hostile critics a handy populist stick to beat back this growing

William Edmonson
Angel, 1932–3, Carved
stone, 18½ x 13 x 5½"
The self-taught Edmonson
was the first African
American to have a
one-person exhibition
at a major museum in
the United States.

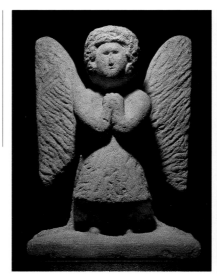

John Kane (1860-1934)
The Girl I Left Behind, 1920
Oil on board, 15³/₈ x 11¹/₈"
Kane's work exemplifies a
native tendency in American
painting: to leap from observed
to symbolic reality, in the pro-
cess sacrificing convention for
eccentricity and expression.

modernist (abstract) horde or at least qualify it. Both Anna Mary Robertson
"Grandma" Moses (1860–1961), whose work was acquired by Otto Kallir, an
art dealer interested in German and Austrian modern movements, and the
self-taught African American painter Horace Pippin (1888–1946) gained
fame in *Life* magazine. Pippin even graced the cover. And the 1957 survey
volume *New Art in America*, organized by curators at the Whitney Museum
and the MoMA, included works not only by abstractionists Willem de Koon-
ing (1904–1997), Jackson Pollock, and Robert Motherwell (1915–1991) but
also by artists who stood almost wholly outside traditions and camps—the
self-taught painters Joseph Pickett (1848–1918) and John Kane (1860–1934),
and Louis Eilshemius, who was himself championed at various times by the
folk-art collector Jean Lipman and Marcel Duchamp, among others.

By the end of the 1960s, the belief that the artist's job is not to create
beauty but to oppose whatever might be the prevailing trend or consensus
became so pervasive that the creative individual could be imagined only as
an outsider. In art, music, and theater, the margin of social acceptability

was the fertile place for the generation of new art forms. It is no accident that William Shannon, the discoverer of the untutored artist Bill Traylor (1856–1949), waited until the 1970s to make only his second attempt to find an audience for the work of this master. His first foray had come in the 1934, through Alfred Barr's Museum of Modern Art.

The leavening ingredient for the acceptance of outsider art was an insider movement, Pop art, which embraced popular culture and imagery in order to question all aspects of art: its materials, meaning, symbols, spiritual content, individual production, even the possibility of its existence. From the "combine paintings" of Robert Rauschenberg (b. 1925), which included everything from found objects to photographic snippets—much like paintings by William Hawkins (1895–1990)—to the use by sculptors, including Robert Morris (b. 1931), of distinctly unsculptural materials such as felt and lead, artists erased conventional distinctions between "high" and "low" art. The distinctions about who could make art and under what circumstances also dissolved. To take a slightly later example from a different

William Hawkins
Untitled (Collage with Steeples), 1988, Enamel on Masonite, 48 x 60"
Omnivorous borrowing: Like many avant-garde artists, Hawkins incorporated found imagery–not as critique but as a shortcut.

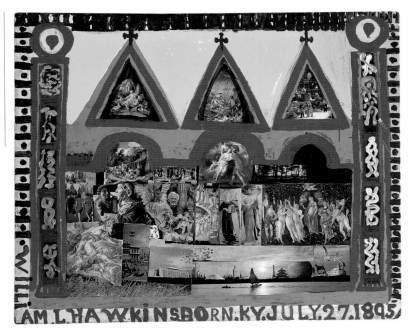

milieu, stage designer Robert Wilson and composer Philip Glass used the speech of people with autism as the basis of their text for the opera *Einstein on the Beach* (1976). At the end of the 1970s, graffiti artist Keith Haring (1958–1990) and the Haitian-born musician and graffiti artist Jean-Michel Basquiat (1960–1988) both entered the New York art world and soon became famous for their faux-primitive and cartoon styles.

Paradoxically, the efforts of many Pop and Conceptual artists to undermine notions of authorship, expression, and individual style had the opposite effect of legitimizing as never before, via irony and distancing techniques, individuality and creative identity. By laying siege to the last vestiges of middle-class taste and the notion of a canon of fine art (which had come to include abstract art), artists such as Andy Warhol (1928–1987) and Chuck Close (b. 1940) ended up plowing the ground for the very sort of raw, expressive, personal art they seemed to regard with skepticism. After Warhol, art might be whatever someone—an "artist"—thought it was, and anyone might be that person, the artist. Pop art may have tried to kill the

Jean-Michel Basquiat
Untitled, 1985, Acrylic and oil stick on canvas, 60 x 48"
Outsider as insider: Basquiat, of Haitian descent, was adopted by the art world for his "primitive" style.

myth that art carries uniquely imagined spiritual and aesthetic meaning, but it only reinforced the myth of the artist as a special individual operating outside the psychological and "lifestyle" norms of society. Although outsider artists didn't participate in these revolutions and acts of historical critique, the appreciation of their work depended on such developments.

Within this context, folk art was reexamined and broadened to include visionary and idiosyncratic material that often had nothing to do with notions of shared local or regional practice. Exhibited in the early 1970s, the comprehensive collection of Herbert Wade Hemphill, Jr., for example, included far more than canes, whirligigs, and quilts, the usual stuff of such gatherings. His sculptural objects, especially, embodied approaches that were elaborate, ambitious, materially complex, and often unsettling. Hemphill had a profound impact on many in the outsider field, including dealers such as Randall Morris, Phyllis Kind, Frank Maresca, and Roger Ricco. In 1974, the Walker Art Center in Minneapolis presented an exhibition of visionary "environments"— including buildings, sculptures, and landscaping—created by single individuals outside the mainstream of professional training. It was the first exhibition of its kind in the United States. In 1981, curator Elsa Longhauser mounted the pivotal exhibition "Transmitters" at the Philadelphia College of Art, perhaps the first in the United States devoted exclusively to "outsider" art.

By far the most important exhibition, however, was the Corcoran Gallery's 1982 "Black Folk Art in America," which presented for the first time exclusively African-American self-taught artists, whose work few mainstream art aficionados had seen. Most of the artists were not true outsiders, but many straddled the line. In any case, artists such as Bill Traylor, James Hampton (1909–1964), Sister Gertrude Morgan (1900–1980), and William Edmonson formed a group now regarded as among the most significant of America's self-taught artists. Apart from the problem posed by mainstream white art historians anointing a select few artists to a pantheon that the artists themselves knew nothing about and that was based on criteria that in most cases had little to do with their work, the exhibition presented

productions of enormous stylistic diversity. It is not too much to say that in one stroke it created a new frame of reference for critics and art historians and a new set of standards for collectors and dealers.

This brief summary scarcely suggests the artistic ferment of the 1960s and 1970s that opened the door to an appreciation of outsider art in America. We offer it to make an obvious point: Outsider art and self-taught art gradually came to be recognized as "art" because of the boundaries crossed by insider artists (and institutions), and so our appreciation of outsider art is colored and enhanced by our knowledge of contemporary and modern art. Of course, this relationship has always been "selectively enfranchising," in the words of critic and philosopher Arthur Danto.[11] That is, the ticket of admission for artistic relevance is always punched by the insiders. Generally, outsiders could not care less for the opinions of an art world in which they do not participate. An even greater irony is that the very artists appropriated by insiders to foment cultural disruption are often engaged in des-

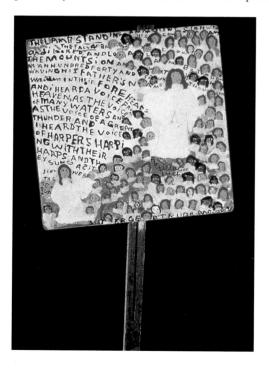

Sister Gertrude Morgan
The Lamb Standing on Mount Zion with His Company, n.d., Acrylic, tempera, and graphite on Masonite with wood post, 23¾ x 23¾"
A church unhoused: Morgan made the street corners of New Orleans her pulpit to deliver her ecstatic holy visions.

perate struggles to organize their inner experience, to quell psychic distur-
bances and achieve some sense of equilibrium. As Danto has also remarked,
it may be that the only really useful definition of an outsider artist is one
who has no awareness that there is an art world. This inequality has practi-
cal implications. Insiders determine not only standards of quality in the
field but also what belongs in it at all and thus what most people are likely
to see. And insiders are not always in agreement. In the end, everyone who
cares about self-taught art must have the confidence to make his or her
own judgments and stand up to "expert opinion," which is often nothing
more than personal taste, prejudice, or disguised economic self-interest.

The other caution about the relationship between modern art and out-
sider and self-taught art (examined in more detail in a later chapter) is that
it is not necessary to take positions for or against this work. As I have indi-
cated, throughout the history of modern art, the productions of people
outside the art world have been used to criticize or buttress various forms
and styles of insider art, from the academic to the experimental. Dubuffet
staked out the most extreme position when he insisted that outsider art was
simply better than insider modern art, which he called "a fallacious parade"
and the product of "asphyxiating culture."[12] In Dubuffet's view, outsider art
was more authentic, spiritual, creative, honest, and energetic. The negative
terms he would apply to modern art are easily inferred: artificial, fashion-
able, refined, professional, intellectual, ironic. This opposition still typifies
the thinking of many aficionados and some critics, but it is mistaken and
unnecessary. There is no reason to give up a great painting by Mark Rothko,
a sculpture by David Smith, or, for that matter, an installation by Cornelia
Parker or a video construction by Nam June Paik in order to appreciate a
work by Adolf Wölfli or Martin Ramirez.

Let the ideologues draw lines; the rest of us don't have to make such
either/or choices, and our imaginative world is poorer if we do. As I argue
repeatedly in this book, the appreciation of outsiders and insiders is insepara-
ble. We need only recognize the differences in historical situation, intention,

context, audience, and expectation in these works that we have designated as art. Works by insiders and outsiders may look very similar but have quite different origins, implications, and meanings. By the same token, the two realms may directly illuminate each other. Artists separate in time and space, as well as in circumstance, may well share deeper sources of inspiration and the same impulse to communicate in visual languages of their own coinage.

In other words, in order to understand outsider and self-taught art, it is necessary to react just as we would in the face of any work of art. We need to consider its form and materials, query its relation to the world, seek out its assumptions, try to divine the artist's intentions, consult our own emotional responses, and make judgments. And just because we may not have seen its like before does not mean it has no precedent and defies any attempt to put it in a context. The more art we see—art of all kinds and periods—the better we will be able to appreciate and judge what is valuable and moving in even the most unfamiliar and challenging work.

Self-Taught and Outsider Art Compared

This book is intended to help make our judgments more astute. At the outset, however, it is essential to draw some practical distinctions. I have been using the terms "self-taught" and "outsider" art more or less inter-changeably and referring also to "folk art." These current usages, and others including "visionary art" and "*neuve invention*," are largely marketing tools or shorthand. They are at best conjectural and probably should be jettisoned in favor of either no labels at all or more restricted ones, along the lines of "*art brut*." In the world of galleries, the terms are encountered constantly, and they often have economic implications. The term "outsider" is at the top of the price pyramid; "self-taught" represents the less exclusive, usually less provocative middle; and "folk art" indicates the broad, accessible, and (with a few exceptions) far cheaper base. It is often important to dealers to promote definitions that allow them to include artists in the outsider category who do not really belong there, and biogra-

Friedrich Schroeder-Sonnenstern (1892-1982) *Meta-[Physik] Mit Dem Hahn, [Meta-(Physic) with Rooster]*, 1952, Graphite and colored pencil on paper, 12½ x 9½" Displayed in Europe in the 1960s, Schroeder-Sonnenstern's images influenced graphic artists such as Peter Max.

phies of even fairly mainstream artists are sometimes skewed to highlight marginal activities and experiences. The reasons for this become clear in the next chapter.

For purposes of this discussion, however, our key terms can be defined in the following way. "Outsider art" is the work of people who are institutionalized or psychologically compromised according to standard clinical norms. The writer John MacGregor has revised this definition to include art created under the conditions of a massively altered state of consciousness, the products of an unquiet mind.[13] This is a compelling designation, in spite of its ambiguity, because it takes into account "visionary" works that owe no allegiance to any shared standards, yet cannot be dismissed as merely deranged. In any case, the most obvious categories of this art are works by people experiencing the symptoms of psychosis, schizophrenia, and autism (so-called savants). In some cases, it also seems clear that severe bipolar disease is a factor. These are clinical categories that, in spite

of ongoing debate about their boundaries, origins, and political character, have proven durable, if not medically practical.

By MacGregor's standard we would also include art created by various insiders who suffered from severe mental distress or experienced hermetic, comprehensive, and monomaniacal visions. We would be further tempted to include in the category of outsider self-taught artists incarcerated for criminal acts whose incarceration is the occasion—even the motive—for their work. In this sense, it might be said that their work is directly a product of their being held outside of free society. Without the extreme constraint, the art never would have been made. This is a controversial position, but it seems clear that artists such as Eddie Arning (1898–1993), Frank Jones (1900–1969), and probably Martin Ramirez would never have channeled their energy into art without the restrictions and in some cases encouragement provided by institutional settings.

While such prison art is not on its face the product of an "unquiet mind," it is bound up with the fact of an isolation so radical it necessarily implies MacGregor's massively altered consciousness.

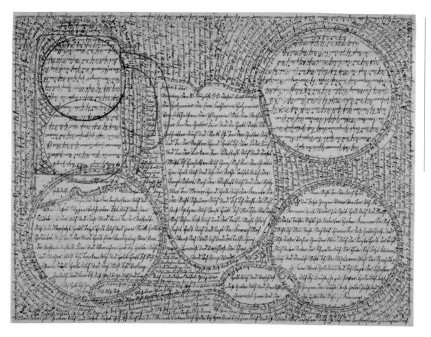

Barbara Suckfüll (1857-1934?)
Untitled ("Sunday. The 21.
August. 1910..."), 1910
Graphite and ink on paper,
13 x 16½"
Institutionalized, Suckfüll
used language to divide
time into instants and to
catalogue her mental
passage through it.

Eddie Arning
Untitled, ca. 1972
Craypas on paper,
25¾ x 20"
The "secondary gain from internment" 1: Arning stopped painting as soon as he left the hospital.

By the same token, the Holocaust provoked an intense need to make art among many of those interned in the concentration camps, whether they had formal training or not. Some worked under the threat of death, some to avoid it, using their talent to bargain for better treatment. Some made art in order to record and remember where they had been, and some made art to forget. It is all too easy to talk of spontaneous creation, as Dubuffet, Cardinal, and many others have done, but more often than not, creativity needs an occasion, and that occasion is often traumatic or disruptive. With perhaps a deadpan irony, the critic and art theorist Michel Thévoz has labeled this aspect of creativity the "secondary gain from internment."[14]

"Self-taught art" is a broad category comprising work that is unschooled and autodidactic. It has been argued by many critics that the category is meaningless, since on the deepest level all artists teach themselves. Certainly from the turn of the last century, the West has seen an almost continuous struggle by artists to unlearn their formal training and to overturn what they have perceived to be arbitrary and oppressive norms. To speak precisely, the amount of *untaught* art is vast, for the rise of professional art schools is a very recent development in the West. Most

Frank Jones
Untitled (Devil House),
1968, Colored pencil on
paper, 22½ x 21⅞"
The "secondary gain from
internment" 2: Jones served
three sentences in prison
and, during the last, began
drawing "houses" populated
with devils and spirits.

self-taught art stands somewhere between paint-by-numbers kits and high-school figure drawing. The people who make it have at least a basic sense of entering into a relationship with an audience, if not with a marketplace. The artist Jim Shaw (b. 1952) parodied—and paid homage to—this vast tide of work in a 1990 exhibition titled "Thrift Store Paintings," made up of paintings he and other artists collected from junk shops, thrift stores, and Dumpsters. The art that interests us in this book, however, is the most independent and we might say unhoused, departing significantly from recognizable norms and models. In some cases, the people who make this work are outside of institutions only by luck, family support, or community indulgence. Often they find themselves at odds with their communities or governments, especially if they construct environments or other public art works. To take the most important example, Nek Chand Saini (b. 1924), who lives in Chandigarh, India, has fought a protracted battle with town officials to preserve his twenty-five-acre "kingdom," containing hundreds of sculpted figures and structures, even though the work has been featured on an official Indian postage stamp.

"Folk art," on the other hand, is created within the context of community traditions, usually craft-based. It is often closely related to decorative, memorial, or utilitarian goals. The artists may be self-taught (often they learn techniques from elders), but their imagery is not generally idiosyncratic or hermetic. It usually incorporates familiar motifs or narrative elements, whose meanings will be understood by the intended audience. In its continuity with the past, folk art is essentially conservative. Until twenty years ago, a common consensus seemed to hold concerning the fine-art status of folk art (second class) and what should be included under its umbrella (untutored representational art). All that has changed, in part because of the Corcoran Gallery exhibition discussed above. Increased attention has focused on individual artists and on their cultural settings. The art of Elijah Pierce (1892–1984), Edgar Tolson (1904–1984), and Sister Gertrude Morgan, all natives of the southern United States, is now seen as deeply rooted in community imagery, most of it biblical. Yet even though their work is repetitive and incorporates commonly understood imagery, from animals to angels, its

Anonymous
Untitled, ca. 1897
Carved wood and cigarette
holders, 40 x 27"
This novelty assemblage
painting, created for
the Chicago Centennial
Exposition, illustrates
the vast store of images
made by itinerant,
self-taught artists that was
once a main element of
American visual culture.

ultimate permission comes from within the artists themselves, not from their communities. The most complex example is Vermont's Gayleen Aiken (b. 1935?). Widely regarded as the prototypical folk artist, she paints memory pictures of many Vermont scenes, including granite quarries and a favorite old house in Barre, Vermont. But this world intersects a complicated, often darker one of fantasy, ritual, and longing for an innocence that she perhaps never knew. Given a difficult personal history, Aiken often seems closer in practice to the classic outsider. The work of such artists is always liable to take unpredictable directions, never fully sanctioned by its audience and their experiences. From our perspective, the term "folk art" should be used primarily in reference to community-oriented, craft-based traditions.

Are these distinctions helpful? Are they not mere impositions on the diversity of human expression in order to package and sell it? Doesn't the term "outsider art" in particular embody a nostalgia for a state of freedom from the constraints of society, a state of being that has probably never existed in the history of humankind? It increasingly seems that way. Perhaps we should follow the advice of insider artist Gregory Amenoff (b. 1948), who insists that we simply look and not name. Chapter Five takes up these questions again, in light of a host of contemporary artists whose work is

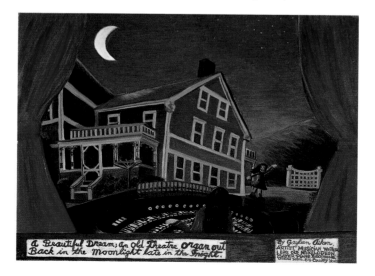

Gayleen Aiken
A Beautiful Dream, 1982
Oil on canvas board, 12 x 16"
Night thoughts: Aiken is a superb colorist, but her best work arises from the dark, which nourishes ritual and creativity.

just as difficult to categorize as that of any outsider and who, in some cases, borrow directly from outsiders. Nevertheless, even though the labels "outsider" and "self-taught" may be debatable in terms of politics and aesthetics, through experience we do gain a sense for work that is created outside the broad matrix of art training, an art world, and a historical awareness of art production. In the case of outsider art, there are recurrent underlying preoccupations, imagery, and even stylistic approaches that seem to accompany extreme psychic states. In the end, most aficionados come to the conclusion that even though they cannot say precisely what outsider work is, they know it when they see it.

Why Outsider Art?

The difficulty of characterizing outsider art and the extreme nature of its communication lead to the question that might well have begun this book: Why look at outsider and self-taught art, if not out of romantic nostalgia for some image of unfettered individuality and expressive freedom? Or is our fascination with this art just one more form of voyeurism? After all, there is plenty to look at and own much closer to home, so to speak. We live in a time of unprecedented artistic production. Thousands of graduates of hundreds of art schools and university programs in the United States alone produce an almost uncountable number of artworks. Multiply that by the growing number of artists in China and India, to take two examples, and the volume of contemporary art making can barely be comprehended. The category "artist" has become a full-fledged professional class like "investment banker," "lawyer," or "computer programmer." We are inundated by art, and in a time when canons of taste have fallen, there is something for everyone, usually with an appropriate pedigree of exhibition and critical certification. In the face of this avalanche, why do we need outsider art?

In the first place, what unites these insider productions is the monocultural assumption that art is a commodity to be selected, collected, possessed, exhibited, savored—and too often dispensed with. The very volume,

diversity, and eclecticism of contemporary art offer a clue to the reasons for outsider art's appeal. To make the point clearer, however, we might consider some works by better-known contemporary artists that are likely to be on exhibition at any given time in the art galleries of New York's Chelsea district.

One gallery displays a suite of large black-and-white photographs of waves breaking on various shores—photographs with a certain drama but whose primary claim on the attention appears to be their large scale. In another gallery are paintings of muted landscapes that appear at first glance to be photographs. In another, objects made of Vaseline. And in still another, various obscene phrases are painted on the gallery's walls. The detritus of mass-mediated culture is everywhere, from Barbie dolls and every kind of plastic figurine to entire automobiles, often scarcely altered or even arranged in compositional schemes. This inventory is a small fraction of what might be seen in a single day in Chelsea, and it is also, of course, biased. Some of the works cited above are arresting and even memorable. What they lack is a sense of necessity.

Regardless of the artists' motives or commitment, the vast majority of these pieces could have been done by any number of other artists, who create works very much like them. They seem to exist for temporary and local purposes that are usually immediately obvious but will become unintelligible in a matter of months, not to say years, when prevailing preoccupations, dominant media imagery, and social attitudes change. And they are almost all products of an education based on the study of works much like themselves. Outside the display space of an art gallery—in a storage area, for instance, or in someone's basement—they often look forlorn, if not completely haphazard or mysterious. The individual identities of works by many of these artists are often irrelevant: If you've seen one, you've seen them all. (Admittedly, this charge has been made against almost every form of abstract art, and against some outsider works as well.) Above all, however, few things on the walls and floors of Chelsea at any given time convey a sense that the artist needed to make them in order to communicate a significant aspect of his or her sense

of reality or of the complicated negotiation of self with world. Nor do many of them embody a sense of significant play or discovery. Rather, the works seem to be tautologies. As Andy Warhol delighted in pointing out, they are art because they appear in an art-world setting, Q.E.D.

Outsider artists tend to invest all of what they can in their art all the time. They rarely strategize their work or hold anything back. They usually lack irony but may display enormous reservoirs of humor and love, not to say anger, shame, bewilderment, and euphoria. The forms and symbols in such work are often unfamiliar, and the direct incorporation of language can be unintelligible, not to say incoherent. The rendering can be crude to the point of incompetence, and taken as a whole, the works of many such artists are exasperatingly repetitive (the same could be said of work by Kandinsky, Picasso, Rauschenberg, Rothko, and numerous other recognized masters). But outsider art derives its power from its very limitations—its sui generis resourcefulness and lack of moderation. As shown in the following chapters, the best works of outsider and self-taught art make the same claims as any great art, that is, they join familiar and unfamiliar realms of experience in symbolic forms. Even lesser works of outsider art

Matthew I. Smith (b. 1938) Untitled, n.d. Graphite on paper, 8½ x 11" An artist with autism, Smith has made drawings embodying an acute sensitivity to pattern—from the groupings of people in the lobby of the Metropolitan Opera to a carpet of lichen.

have the capacity to express a demanding urgency and to testify to the overwhelming reality of being alive.

While many contemporary works lose meaning and interest as soon as they are removed from a gallery setting, outsider works, by contrast, cannot be blunted or silenced by their importation into galleries and museums. Indeed, they often look incongruous and manage to embarrass not only the works around them but also the entire commercial enterprise of buying, selling, and exhibition. In some cases, we feel that they should not even be looked at, except in private, and perhaps not even then.

Admittedly, this sounds a bit like Dubuffet, bashing mainstream art with an idealized view of insanity's expressive purity. We are not, however, proposing that outsiders are always "uncorrupted" by culture or that they have no relation to an audience or that they are "natural" creators, only that their creations do not involve strategies, either of accommodation or rebellion. They are, in some profound sense, beyond norms. Robert Greenberg, one of the foremost contemporary collectors of outsider and self-taught art, has focused on the compulsive urgency as the key element of outsider art, one that stands somehow over and above all formal and aesthetic properties. It is this communicative urgency that gives rise to the unusual forms and the vast, comprehensive visual schemes that represent other worlds or other languages. As Greenberg wrote in the catalogue to his collection:

What I saw in the paintings of William Hawkins, Drossos Skyllas, and others were pure, uncompromised ways of seeing and making art. Their creative will lay beyond any borrowed vocabulary and even beyond the need to communicate. They pointed me to a realm of artists whose primary relation to themselves and the universe is in the act of artistic creation. . . . They are visited by powerful forces that, through their work, can touch us, too.[15]

This is not to say that anything lacking such a level of necessity is dispensable. Art can be there just to cheer us up or point out something we have

Silvia Reinstein (d. 2004)
Untitled, Acrylic on paper
with painted frame, 26 x 20"
Art and desire: Many self-
taught artists embrace
image-making as a means
of experiencing other times
or places. Reinstein, for
instance, painted works
inspired by Japanese prints.

overlooked or taken for granted. At the same time we need to be able to rec-
ognize necessity in the most self-conscious of contemporary art works—not
to mention the works of past artists who may now seem no more than names
in history books. In its often fierce and narrow consistency, outsider art can
confirm certain experiences that may be at the foundation of all art, and thus
can enhance our generosity toward art in its many forms. It can teach us that
art builds worlds; that is art's power. It is constitutive rather than denotative.
Its power lies not in its ability to image some preexisting reality but to bring
things into being, to reconstitute the world in acts unhinged from canonical
forms and conventionalized rituals and ways of seeing. These acts become the
occasions for our connection. I prefer the term "reconstitute" to "envision" or
"express," which implies another level of reality prior to and above the act of
making. For artists—whether or not they know themselves to be artists—the
made world is really the only one there is, the repository of knowledge, per-
ceptual acumen, the hand's energy, the body's faith, the soul's doubt.

The Lure of Madness, the Thrill of Crime

2

"Who has not known those miraculous moments—veritable feast
days of the brain—when the senses are keener and the sensations
more ringing, when the firmament of a more transparent blue
plunges headlong into an abyss more infinite, when sounds chime
like music, when colors speak, and scents tell of whole worlds of
ideas?"[16] CHARLES BAUDELAIRE

The snake has all the lines.

This humorous adage about the seductiveness of the serpent in the Garden
of Eden makes light of a darker truth, the continuing fascination in Western
art and culture with themes of evil, crime, and madness—in short, the
essence, in the popular mind at least, of outsiderness. The roots of this fasci-
nation are endlessly debatable. At the most fundamental level, it is bound up
with the primordial mystery and terror inspired by certain experiences that
mark the border between the familiar and the incomprehensible, the temporal
and the absolute—experiences that have the power to obliterate an individ-
ual's sense of self. Those fundamental experiences are birth, sex, death
(including the killing of animals and enemies), and frenzy. According to
theorists from Friedrich Nietzsche and Sigmund Freud to the contemporary
French philosopher Georges Bataille, it has always been necessary to bind
these confrontations with absolute otherness by erecting taboos around them,
so that they can be accommodated into social life without utterly disrupting it
and breaking apart its forms. At the same time, the taboos also prescribe rules
for their own rupture, so that it is possible under appropriate circumstances
to experience the self-expunging otherness, to gain glimpses of a world
beyond the self and partake of a power not our own. Philosophers have called
this experience by many names, including the Holy and the Sublime.

Michael Madore (b. 1954)
Quasimorte, 2004
Ink and acrylic
on paper, 25 x 19"
One aspect of transgressive
art is its fragmentation and
exaggeration of the body, as
with Madore, a trained artist
with autism, whose extreme
vision places him on the
boundary of outsider art.

Visual art has probably always been involved with the rituals celebrating and containing the experience of otherness. Whether such artifacts as the animal cave paintings of southern France or the Neolithic fertility figures of central Europe are taken to have had a magical function (a theory now largely discounted), they were not casual productions. They were connected to matters of life and death, matters in which representation clearly played an important role. Yet as the West began to develop socially and technologically after the twelfth century, primordial taboos were replaced by a far more elaborate system of legal and social prohibitions governing broader and broader aspects of behavior—the "civilizing process" as sociologist Norbert Elias has termed it.[17] That process was also predominantly Christian in its positive and negative valuations. Sigmund Freud (1856–1939) argued that this repression of instincts and the tight binding of limit experiences was the necessary price to be paid for reaping the benefits of productive civilization. Almost from the beginning, however, voices were raised in protest. The more rationalized daily life became, the more distant, mysterious, and attractive became its opposite. In the literature of the late Renaissance, just as the modern world was being born, thieves,

sharpers, highwaymen, rogues, voluptuaries, and—most famously in the person of Don Quixote—madmen began to take center stage. By the end of the nineteenth century, the problematic relation of the individual to all social norms, not to mention religious norms, replaced marriage as the central preoccupation of Western literature. Madness, crime, and apostasy, hopeless though they might be, came to be seen as forms of rebellion and assertions of creative freedom. As the poet Arthur Rimbaud, who was in fact a criminal, wrote in 1871, "Now I am debauching myself as much as I can. Why? I want to be a poet. . . . What is needed is to make the soul monstrous."[18]

The visual arts followed a similar but less obvious path, perhaps because the channels of production and the display of art, as well as the commercial structures that supported artists, were narrower than for the written and printed word. But it is certainly possible to trace a lineage of visual transgression from, say, the deliberate inversions of myth and quotidian reality in the religious paintings of Michelangelo Merisi da Caravaggio (1571–1610)— a reputed murderer—through the fascination of artists such as Diego Velázquez (1599–1660) for dwarves and beggars to the dance hall prostitutes drawn by Henri de Toulouse-Lautrec (1864–1901), erotic portraits by Egon Schiele (1890–1918), and a host of other forbidden or provocative representations, up through the photographs of Joel-Peter Witkin (b. 1939) with human freaks and severed heads, the divided animal carcasses of Damien Hirst (b. 1965), and the sexualized children of Jake (b. 1966) and Dinos (b. 1962) Chapman. As late as 2001, when the latter three British artists were exhibited at the Brooklyn Museum, in the exhibition appropriately titled "Sensation," they managed to provoke an outcry in the most art-jaded city in the world. The closer we look at Western art, the more it appears that the critic Dave Hickey was right to say that the function of art is simply to valorize the most problematic, not to say outrageous, content.[19]

Just as the modern mind has a tendency to think of history as a constant overturning of one era by another, one world view by another, one school or style by another, so it is essential to the modern secular sensibility, from

Joel-Peter Witkin
Still Life with Breast, 2001
Toned gelatin silver
print, 16 x 20"
Witkin's photographs
exemplify the continuing
attempts of Western artists
to transgress the boundaries
of the acceptable image.

which a close, even oppressive, sacredness has all but vanished, to think of art as the constant transgression of norms, of pushing into territory previously forbidden to representation. The two ideas go together and help explain the climate for the appreciation of outsider art. The outsider artist Henry Darger created vast panoramas depicting the violation and murder of prepubescent girls. His work could not be exhibited today, much less applauded, unless the context of acceptance had evolved and the doors of appreciation had somehow opened. It is the same cultural situation that sanctions the exhibition and appreciation of transgressive work by insider artists such as Hans Bellmer (1902–1975), Robert Mapplethorpe (1946–1989), Paul McCarthy (b. 1945), and Cindy Sherman (b. 1954), to name only a few.

This is not to say that the transgressions of the insiders and the outsiders are the same. In general, modern artists are fully conscious of flouting norms. They are troubled not so much by belief as by the lack of it, as though art were a punching at the void. With outsiders, a supreme principle or force, occasionally demonic, is often a given. Transgression is a way of engaging that power directly or summoning it.

Beyond sex and death, another line of art traverses the territory of madness, obsession, and derangement. This tradition, which can be regarded as an aspect of the more general category of grotesque art, includes early images of madmen rendered by Renaissance masters such as Hieronymus Bosch (ca. 1450–1516) and Leonardo da Vinci (1452–1519), the nightmarish scenes of Henri Fuseli and Francisco de Goya (1746–1828), the grimacing sculptures of Franz Xaver Messerschmidt (1736–1783), who may himself have been mad, the "Bedlam" engravings of William Hogarth (1697–1764), any number of hallucinatory works by English Pre-Raphaelite painters such as Edward Burne-Jones (1833–1898), and twentieth-century works by Odilon Redon (1840–1916), Edvard Munch (1863–1944), and many Surrealists.

But what about art actually created under the pressure of extreme mental states—from inside the realm of madness? As we pointed out earlier, the idea of art as kin to madness has been with us for millennia. "There is no invention in him until he has been inspired, and is out of his senses, and the mind is no longer in him, " wrote Plato in the "Ion" more than two thousand years ago.[20] Since then, the notion of art arising from madness has been treated inconsistently by critics and historians. For example, the seventeenth-century Dutch painter Pieter de Hooch (1629–1684), who is often compared with Vermeer in style and sensibility, spent his last years making paintings clearly tinged with mental instability. These paintings are rarely displayed and almost never reproduced in catalogues, having been deemed inferior and uninteresting by critics. On the other hand, England's Richard Dadd would be justly relegated to art-historical footnotes if he had not experienced the severe mental illness that completely altered his art, opening it to visionary and paranoid imagery. Nevertheless, the "mad" paintings were ignored in their time by almost everyone but Dadd's physician, and Dadd was considered "lost" as a person and artist when he entered the asylum. The most famous early example is Vincent van Gogh, whose mental condition and its relation to his painting has been endlessly analyzed.

The point is that in most cases, the work of people in psychologically dire straits has been regarded as largely without aesthetic value because it deviated so far from aesthetic norms. Some images were labeled fantasy, some acknowledged as artlike productions but seldom as art per se. The idea that images might be worthwhile precisely because they deviated did not occur to critics—or artists, for that matter—until the middle of the nineteenth century, when poet and critic Charles Baudelaire saw in apparently classical painters such as Jean-Auguste-Dominique Ingres (1780–1867) and Eugène Delacroix (1798–1863) the deviations that heralded a new, more individualistic art.

As noted above, there have been medical practitioners who became fascinated with art made by their psychiatric patients and began to collect it, but their interest was primarily medical and diagnostic, not aesthetic: What could art reveal about madness? Indeed, art was even used as evidence of deviance in order to keep patients locked up against their will.[21] In 1905, however, Dr. Paul Meunier (1873–1957), writing about the collection formed by Dr. Auguste Marie at the hospital of Villejeuf, France, was perhaps the first to engage this work on purely aesthetic grounds, presenting and evaluating it in terms of forms and practices. He insisted that this art was something more than merely chaotic, nonsensical, or desperately alien. Comparing it with the canons of accepted art, he concluded that the works of the insane revealed the primordial psychic preconditions of all art-making, including the sophisticated practices of the conventionally trained artist.[22]

In Meunier's presentation, we can see the outline of what would become an article of faith among collectors and supporters of such work: The outsider, the insane artist, is a primitive demiurge in touch with creative forces that culture only suppresses. This myth or combination of myths, for that is what such ideas must be called, would energize much modern art, from Picasso's early Cubism to Abstract Expressionism and beyond. It would also provide justification for the view of totalitarian regimes that modern artists were fundamentally degenerate and antisocial. In an ironic reversal of the

appropriation of outsider perspectives, the Nazis made little distinction between avant-gardism and insanity. As artists adopted the notion of their own necessary or de facto alienation from society, madness came to be seen as a pathway to stylistic liberation and wholly individual, authentic modes of expression. In this view, the artist—not just the outsider artist—has no inner choice but to make art and has to make it his or her own way. As Jackson Pollock put it, "Painting is self-discovery. . . . Every good artist paints what he is."[23]

Given such a climate and the tremendous pressure placed on contemporary art to press ahead, to be "new" and "innovative," the serviceable idea of the genius has undergone a transformation beyond the iconoclast, visionary, and rebel into someone working at the most distant fringes of communicative action, and often whose own suffering is considered extreme. We are perhaps interested in Pollock now as much for his self-destructive exploits as for his art, and the popularity of such films as *Shine* (1996) and *A Beautiful Mind* (2001) testify to a broad belief that talent and intellect spring from minds not in control of their experience. The renewed popularity of Caravaggio's work and the increased attention paid to the drawings of the actor and writer Antonin Artaud (1896–1948), who spent time in a mental hospital, underscore the persistence of the myth of art as a form of deviance. The key figures in the new pantheon of visual extremists are artists such as Adolf Wölfli, Martin Ramirez, James Castle (1900–1977), and Henry Darger. Sixty years ago, self-taught artists were valued for their populist and vaguely surreal content. By far the best known was Morris Hirshfield (1872–1946). His highly patterned paintings, influenced by his garment work, juxtaposed often stereotypical figures with repetitive backgrounds and figural elements. Yet Hirshfield himself wanted only to paint sentimental and conventional portraits. Now many artists of an earlier time, regardless of the virtues and compelling peculiarities of their work, have disappeared from discussions of outsider and self-taught art, and Wölfli, who went unexhibited in this country for decades, long after his reputation was established in Europe, is a well-known name in the art world, even among those inexperienced with outsider art.

Is It Art?

The marketplace notwithstanding, can the productions of people under extreme psychic duress communicate to us as "insiders," and how must we change our attitudes about art in order to appreciate these works? We need to tread carefully, and not just because these works have the power to unsettle. They may not be art after all, at least as we usually understand the word, and what we are doing when we judge or acquire them may be just another version of what Marcel Duchamp (1887–1968) did in displaying "readymades," that is, we are arbitrarily labeling a certain thing art when it has no more aesthetic intention behind it than a porcelain toilet bowl or a bicycle wheel, the most famous "creations" of Duchamp's oeuvre.

Many psychological theories, including Freud's, are based on the supposition that art is evidence of an individual's failure to achieve maturity and a fully integrated personality, one that effectively reconciles internal desires and external demands. Art making sublimates unresolved infantile conflicts and wishes into acceptable (or barely acceptable) substitute forms of gratification. In this scheme, even the most respectable, conservative art is already close to pathology and deviance. Disciples of Freud such as Melanie Klein and others, however, stressed the creation of objects as integrative for the development of personality, and D. W. Winnicott went farthest in seeing artists as heroic figures, operating between fantasy and oppressive reality to create new forms that bond the artist more dynamically to the world.[24]

There is an assumption with all these theories that the people making the works are aware that what they are making is art, or at least a representation of some kind, that it has a place in the structures of the social world and is a bearer of meanings in some intentional sense, even if the meanings are obscure and open-ended. The art of outsiders challenges these basic assumptions. Many outsiders have no sense that what they are making is an independent, expressive aesthetic object, whose purpose is communication and whose destiny is to be appreciated and contemplated by others, to be integrated into their world. In spite of the fact that works by outsiders are

distinctive and apparently expressive, there is often a chilling impersonality about them, an indifference to any audience and to themselves as individuals. In some cases the "art" is a form of private communion, in others an apparently mechanical activity, and in still others the transcription of urgent communication from sources beyond the self. But the messages test the limits of intelligibility. In the case of Emery Blagdon (1907–1986), the work approaches magic. The hobo who settled in central Nebraska built elaborate "healing machines," wire constructions that were meant not to communicate a vision or express any emotion but to cure illnesses. Yet they have been preserved and displayed as art.

While psychiatrists have tended to label such works as symptomatic and "readable" primarily in therapeutic terms, Michel Thévoz has declared them "exempt from meaning" and has gone so far as to add that "while they may yield certain revelations, these never carry us back to an antecedent

Emery Blagdon
Untitled (Healing Machine), detail, n.d., Metal, wire, light-bulbs, and other materials, various dimensions
Blagdon claimed that people who came into the proximity of his machines, housed in a rural Nebraska shed, "felt better" after the experience.

reality or a psychic prehistory."[25] Needless to say, for Thévoz, any attempts to "psychoanalyze" or otherwise infer clues about the "causes" of extreme psychic states from such art are mistaken. Thévoz's position is radical. For one thing, it fails to acknowledge the ways in which the art of schizophrenics, for instance, may draw on the artist's memories and direct experiences, as in the cases of Ramirez and Wölfli. Still, Thévoz does warn against reductive medical explanations that would prevent us from experiencing the full suggestiveness of this art.

The work of outsiders challenges other assumptions about art. Outsiders often do not create works at all, that is, discrete objects or performances. In the case of those who fashion environments, such as Ferdinand Cheval (1836–1924), who spent thirty-three years building his *Palais Idéal* from stones he collected, or Edward Leedskalnin (1887–1951), who constructed a castle complex near Homestead, Florida, out of blocks of coral he quarried, the "project" is a continuous act. It ends only when life ends. On the other hand, art-making can be fortuitous and situational, something that starts and stops seemingly without explanation, as we have seen with people who have been incarcerated. Clément Fraisse (1901–1980) began carving wood panels when he was committed to an asylum for attempting to burn down his family's house using a bundle of money he had stolen from it. During some six years in the asylum, he managed to carve 189 panels using only a spoon. The rows of repeating abstract patterns and figures suggest an unfolding narrative, an ordered, sequential communication, but the "artist" never revealed his motives or the project's meaning for him. The work occupied him until his release, at which point he stopped and never resumed. We recall Thévoz's phrase about the secondary gains of internment. Clément exemplifies the freedom that prison denies with one hand and gives back with the other.

Outsiders also challenge the idea of the production of unified images. In the case of many who draw and paint, the single sheet or canvas can be nothing more than a field of nearly random, concentrated activity, as in the case of Ray Hamilton (1919–1996), whose drawings combine images, numbers,

Clément Fraisse
Untitled, ca. 1930–31
Carved wood, 67 x 151"
Marking time: Clement's
189 panels, produced while
in solitary confinement,
have the order and repeti-
tion of a written text and
combine figuration with
abstract signs.

and scribbling. If the sheet or medium is an occasion and the art making an atavism, the end of the sheet is merely a lacuna, not a definitive boundary or an end. The work is never really finished, only interrupted until, for whatever reason and however many sheets later, it stops.

Likewise, for most outsiders, the notion of the individual masterpiece does not apply. As discussed in the next chapter, it is often swallowed up in a tide of productivity. These artists do not and usually cannot make distinctions about the merits of one production versus another. They freely repeat themselves, even to the point of exact duplication. They rarely "develop" or "mature" in the sense of charting a course through new imagery and stylistic modifications appropriate to new subjects, with each departure the consequence of what has come before. As mentioned above, they frustrate all the intellectual frameworks that art historians and critics have developed to understand art and that connoisseurs depend on to appreciate it. We might call outsiders vertical artists in a horizontal world.

Two broad categories of so-called mental illness—schizophrenia and autism—force us to ask the question, "Is it art?" The taste of our time has rehabilitated this work for appreciation and commercial sale, but that does not resolve the question, nor does it promote genuine understanding of the works themselves. To survive and find an audience, the work must endure both the current fashion for transgressive imagery and biography and, con-

Ray Hamilton
Untitled (Hand and Cane),
1990, Ballpoint pen
on paper, 14 x 11"
In many of Hamilton's
ballpoint drawings, the
image seems to trigger a
burst of script or numbers;
the elements unite in
his signature, which is
not so much printed
as constructed.

versely, the many attempts to limit the art's relevance by labeling it with a narrow symptomology.

Art and Schizophrenia

When Adolf Wölfli, an itinerant Swiss farm laborer, began to molest young girls and to erupt in fits of violent anger, he was institutionalized in the Waldau Asylum, near Bern. He was prone to hallucinations and continued violent outbursts. But after some years of confinement, he began to draw, creating a vast output of pastels and collage works now regarded as the single greatest achievement of outsider art, although its full intentions and organization remain obscure. Wölfli had no training in art, music, geography, theology, science, or any of the other disciplines that enter into the more than twenty-five thousand pages of his work. From a medical perspective, his vast oeuvre, with its attempt to describe an alternative scheme of the universe, represents the locus classicus of schizophrenic art.

While the causes of schizophrenia are most likely developmental and physiological, its effects are psychic and behavioral. At least since the eighteenth century the display of its symptoms has been considered unacceptable by Western society, and those suffering from it have been cordoned off as much as possible into psychiatric and criminal institutions. Schizophrenic art has generally come to us from such institutions, most recently through art therapy programs. In the past, this artistic production was usually destroyed as a symptom of disease or even as a contributing factor.

One way of characterizing schizophrenia is to say that an individual's personality is not integrated, that it lacks a stable center of gravity—an ego, to use another term—enabling it to organize impulses, mental events, and responses to outside stimuli. An ego is not a thing, like a suit of clothes or a physical place in the brain, but a dynamic state, an equilibrium, a background continuity. In extreme cases, the mind is vulnerable to hallucinations and delusions, usually paranoid, that cannot be distinguished from objective conditions. Uncontrollable sexual impulses, wish-fulfillment fantasies, and linguistic associations and substitutions buffet the psyche and turn the self into a porous vessel. The sensed boundaries of the physical body, too, are broken. What is natural, even one's own body, may be perceived as an artificial, even sinister construction, and the living aspects of things are often treated as mechanical. Psychiatrists such as Géza Roheim and others have drawn parallels between magical thinking and schizophrenia, especially in the tendency to take thoughts literally and to believe that will and desire, as much as any physical action, directly control events.

Against this backdrop, art making takes on a different and compelling significance. The importance of the artistic process shifts from "representation" or "expression" of mental states to action itself, desperate attempts to order the elements of personality. For most "normal" people, culture, internalized via the social codes of language, contributes greatly to the process of integration and individuation, to establishing the boundaries, distinctions, and discipline of mental and social life, and even to perception itself.

Opposite: Adolf Wölfli Untitled (Der Grund-Reisen-Fontaine-Strahl [The Ground-Giant-Fountain-Stream]), side A, 1913 From the *Geographic and Algebraic Books*, Graphite and colored pencil on paper, 37 x 28½" Composing in books, Wölfli steadily expanded his narrative from autobiography to fantasy; in the seven *Geographic and Algebraic Books*, he detailed his travels in the universe and its transformation into "St. Adolf-Giant-Creation."

With schizophrenia, however, it appears as if each person becomes individually responsible for making the entire universe manageable, with ill-fitting tools and confusing, incomplete, and often contradictory instructions. Language has to be unlearned, so to speak, and reconstituted from the inside, visual conventions reinvented, and sight itself reoriented. Representation of some kind, either in words or images, often provides the means. The schizophrenic Mary Barnes (1923–2001), who eventually overcame her illness, has given an astonishing description of the life-or-death intensity of the baffling struggle for integration as she experienced it while painting, a struggle that combined religion and aesthetics:

> The Temptations of Christ was a canvas nailed to a wall in the Dining-Room. I started it; the Devil came on, horrible, the Devil, the Devil. God, make him come bad. How is it? I waver. No, let him come, how he wants. Now the temple, gold. The mountain, all colours. The desert. Use the stick end of the brush. Quick, quick. Christ is silver, cool. More orange and yellow. I'm mad with the force of orange and the sheer light of yellow. The Devil is clawing and clutching. Christ is smiling. He is still. It's a painting. It's finished.[26]

This interior disclosure allows us to grasp the urgency and scope of the visual art—and writing—of many people with schizophrenia, and of psychotic individuals as well. Because there is potentially so much to be arrayed and categorized at any given moment, the art tends to be comprehensive, omnivorous, and elaborate. The organizing schemes may be intensely focused, but nothing eludes them. The art can also be disjunctive, populated by incomplete, merged or bisected figures, as in the case of the portraits of Heinrich Anton Müller (1865–1930), which appear to be always about to melt into formlessness. The artist known as the "French Traveler" (active around the turn of the last century) combined two distinct styles, one a delicate realism, the other a dynamic, elaborately patterned decorative eruption. Because the art of schizophrenics involves unresolved

Heinrich Anton Müller
Untitled (Two Faces),
ca. 1917–22, Black crayon
and chalk on wrapping
paper, 33½ x 31½"
In the art of people with
schizophrenia, the borders
of pictorial subjects can be
porous, and forms can seem
to invade each other.

The "French Traveler"
Le Pays des météors
[*The Land of Meteors*], 1902
Watercolor on paper, 24 x 18"
The appearance of two
radically different styles in
this work may signal a split
consciousness, for which
the title provides an
apt metaphor.

Marc Lamy (b. 1939)
Untitled, 2001
Ink on paper, 26 x 20"
A horror of empty space?
Many outsiders conclude
an image only when the
page is completely filled.

conflicts and ambiguities, it tends to be repetitive, the result of itches that must forever be scratched. Because its basic impulse is not to copy something but in some magical sense to forge order, the art tends, in painting and drawing at least, to be flat or otherwise unconcerned with realist visual conventions such as depth and proportion. The symbolic and emotional/physical relationships are much more important. And because for these artists the very act of object-making is itself an episode of integration, the art can often indulge gestures for their own sake, violent or playful games without any communicative purpose. While the artist works, he or she defers chaos and suspends contradictions, and the gestures of art become acts of temporary liberation, even in the midst of anger and fear.

In the past, theorists confronting the fanatically detailed images of Wölfli or Augustin Lesage (1876–1954), have reverted to the term "horror vacui," the horror of empty space, to describe the impulse behind schizophrenic art. In their opinion, the art sprang from a primary compulsion to fill the page. As suggested above, this is misleading, even wrong. Empty space

holds no terror per se, and as Thévoz points out, the creative process is less one of horror than of experiment, a kind of desperate play, whose end is the glimpse of a provisional order, which falls apart and must be sought again. This is another way of saying that in schizophrenia, art is never part of the problem but always part of the solution, always evidence of an effected reconciliation between inner and outer experience. As critic Hal Foster puts it; "Far from avant-gardist in its revolt against artistic convention and symbolic order, psychotic representation attests to a mad desire to reinstate convention, to reinvent order, which the psychotic feels to be broken and in desperate need of repair or replacement."[27]

At this point, we might ask: If such "art" does not necessarily attempt to construct coherent images or communicate a message, or if the message is so deeply sequestered that its intended meaning cannot be coaxed out by any audience, what value can the work have for us? These questions seem

Carlo Zinelli
Untitled, 1969
Gouache on paper,
27½ x 19¾"
The experience of World War II and internment in a confining psychiatric hospital seem to find expression in Carlo's situating of the individual human figure as one among many, crowded by the war's instruments, including airplanes and rifles.

to miss the most cherished virtue of art, certainly for critics, that is, its "depth," its multiple levels of available significance.

One answer is that works of art can seize our attention and make a connection in other ways. First and foremost, the work of these outsiders can show us forms in combinations and relations that have never been forged before. The imagery can act as visual poetry, illuminating in a sudden flash the fugitive connections between things and ideas, or forms and feelings, as when Carlo Zinelli (1916–1974) replaces the eyes of his figures with whorls. The psychologist Anton Ehrenzweig has suggested that art takes advantage of two modes of perception, the gestalt mode, which recognizes codified, familiar forms, and the gestalt-free, in which forms have not been analyzed, pinned down, and made familiar by the mind.[28] The gestalt-free forms remain suggestive, open, potentially disruptive, but also stimulating. Both modes of perception operate unconsciously, although the gestalt is learned, and artists are able to take advantage of both. Outsider artists tap the latter to an extreme degree. They offer us connections, often very tenuous, between what is familiar and what has never been seen. For example, in

August Natterer
Hexenkopf [*Witch's Head*], n.d., Graphite, watercolor, and ink on varnished card, 10⅕ x 13½"
Exhibited in the Prinzhorn collection, this work reveals Natterer's merging of naturalism and symbolic fantasy, which had a significant impact on both Paul Klee and Max Ernst.

Oswald Tschirtner
.M.D.XXI.H.H., 1975,
Chinese ink on silk
paper, 8⁷⁄₁₀ x 11³⁄₅"
Unlike his signature "head-
footers" (see pp. 146-7),
one of Tschirtner's early
drawings is a brilliant copy
of Hans Holbein's painting
of Christ entombed—a
complex homage that belies
the notion of outsiders
as artistically isolated.

his best-known image, the artist August Natterer (1868–1933) imposes the profile of a grotesque medieval face upon the pattern of a landscape. The deeper connection between the elements is not at all clear, and yet the image is unforgettable, and opens up surprising interpretations the longer it is contemplated. Likewise the elongated, often armless and multilegged figures drawn by Oswald Tschirtner (b. 1920), a resident patient of the Gugging Clinic, manage to straddle a delicate line between whimsicality and anxiety. They suggest, among other things, that human beings are amoebic forms but with the uncanny ability to think. Like so much outsider imagery, Tschirtner's stubbornly refuses to "die into literalness," as the linguists say about metaphor. It is inexplicable and familiar, a symptom and something inexhaustibly more.

As much as the art of schizophrenics seems to force us to hunt for intended meanings, to seek the concepts that might organize a work (similar to contemporary Conceptual art), we must realize that ultimately it is we, the observers, who make the meaning. To hunt for it in the psyche of the creator is chimerical. To believe it inheres exclusively in the order of the work—an order that may be unintelligible—is fruitless. We are to discover

Guillaume Pujolle (1893-1951)
Untitled, n.d., Gouache and
pharmaceutical products
on paper, 9^1/$_5$ x 12^2/$_5$"
A combination of sharp
geometries and fluid
arabesques characterizes
all Pujolle's photo-based draw-
ings, as if he were attempting
to reconcile a fundamental
opposition in visual (and
perhaps psychic) reality.

personal resonances and visual analogies with other art. The structure of
the work sets the parameters of what we see, but we intuit or deduce fur-
ther connections within the work itself and to our own experiences. Only
then does the work acquire meaning.

Art and Autism

When Jonathan Lerman (b. 1987) was barely three years old, his parents
noticed that instead of continuing to develop normal intellectual abilities,
he began to withdraw from the world around him. His capacity to speak,
play, experience emotion, and relate to others began to erode. Intensive
therapy and special schools could not bring him back, and he slipped into a
sort of arrested life. He was diagnosed with autism, a neurological disorder.
Then, suddenly, at the age of ten, he began to draw. He did not compose
stick figures and crude backgrounds, as children usually do, but parts of
faces, eyes, mouths, and noses stylishly rendered. In a short time, he was
drawing entire portraits, some from life but most from impersonal sources
such as television and magazines. He worked rapidly and with uncanny

expressiveness, capturing the essence of his subjects in sharp, sweeping lines and smudged shadows. He was a prodigy, a savant of the charcoal crayon.

In clinical parlance, Lerman suffers from a severe form of autism known as Kanner's autism. A less serious but more prevalent form is known as Asperger's syndrome. Kanner's autism is often associated with prodigious achievements in a single narrow area—rendering, calculating, memorizing, or playing music, for instance. Autistic artists like Lerman live in a largely visual world, which they can render but not interpret symbolically, a world very different from the schizophrenic, whose constant task is interpretation. According to neurologist Oliver Sacks, these so-called savants lack the very basis of artistic expression, the capacity to transform what they see—imagination. They are rendering machines, and their work cannot be regarded as purposeful, symbolic communication. At a deeper level, according to Sacks, people with autism lack what imagination itself depends on, the ability to experience their own inner states or intuit them in others. In the words of

Jonathan Lerman
Untitled, 2002
Charcoal on paper, 24 x 19"
Art and autism 1: Criticized as mere "rendering machines," artists such as Lerman continuously make interpretive choices in their work; in his case, shading and smudging are especially important.

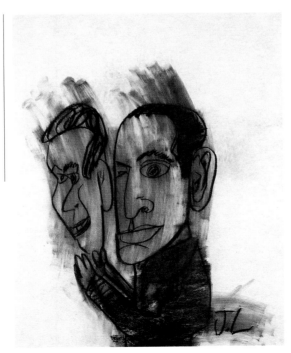

Laan Irodjojo
Red Train, 2001
Acrylic on paper,
27½ x 39½"
Art and autism 2: Irodjojo, of the Netherlands, transforms the world around him into an architecture of intricate lines and broad planes of color.

the author Temple Grandin, who is herself autistic, such people confront other human beings like "an anthropologist on Mars."[29]

According to this description, the "art" of people with autism springs full blown and can never develop, since they accumulate no intrinsic creative awareness of past work against which to measure current creations. Their productions are, in Sacks's telling phrase, "raw, pure expressions of the biological," their lives "a collection of moments," vivid, isolated, devoid of any deeper continuity.[30] As Picasso famously remarked, there are no prodigies in art. That is, art is the product of experience and reflection as much as it is the expression of raw rendering talent. Beneath the dizzying variety of styles and abilities of artists with autism—styles as different as the precise multicolored architectures of Jessica Park (b. 1958), the rough-framed, goggle-eyed self-portraits of Larry Bissonnette (b. 1957), the graphic industrial fascinations of Laan Irodjojo (b. 1969), and the bold gestures of Lerman— lies an unreflective, unchanging void, a negative nirvana.

This is the theory. But the works themselves suggest a more complex reality. For one thing, all savants are not created equal. Yes, many seem to be rendering machines, but just as many defy this description. Lerman's art is rich

in split-second formal decisions, tied but by no means shackled to their visual subjects. He interprets and transforms what he sees in unexpected and revealing ways. He captures Bob Dylan's feral quality and the complicated expression of a woman in three-quarter profile, looking down with one eye and away with the other. As with any artist, Lerman's "style" appears to be a matter of instinct and feel, like a second skin, arising from a place that language and symbols cannot fathom. His practice engages both the body and the mind. A feedback loop forms between hand and brain. With great draftsmen such as Picasso, Matisse, and probably the prehistoric artists of the Lascaux caves (they weren't all created equal either), Lerman shares the urgency and satisfaction of mark-making. It is a kind of nirvana, after all.

Jessica Park's paintings have features of the classic savant: precise and unerring rendering, consistent treatment, strange impersonality. She, too, came to proficiency with almost no preamble. Yet her paintings are not

Jessica Park
The House and the Stoned Lion, 1992, Acrylic on paper, 20 x 14"
Art and autism 3: Although Park made drawings as a young girl, her painting style did not evolve from earlier work but appeared fully developed in adulthood.

so much renderings as assemblages of elements that make her feel good or are important to her: houses, details of buildings and bridges, often set against the background of the night sky, whose stars shine in patterns of her choosing. The schemes of banded color that make the paintings so abstract arise from her own carefully worked-out system of emotional color significances. Park often makes paintings for specific people, but her work is not explicitly intended to communicate some "vision" or express an inner state, although she will insert zigzag lines in her skies to indicate headaches. If anything, her work communicates the pleasure of its making, as an elaborate and consuming form of play.

Bissonnette offers the most dramatic challenge to the narrow view of autistic artists. Unable to communicate for much of his life, he began to make paintings through contact with rural Vermont's Grass Roots Art and Community Effort (G.R.A.C.E.) program, founded by the artist Don Sunseri. Bissonnette paints landscapes and rough, blocky portraits of people, almost always wearing glasses, and includes collage elements as well as certain repeated numbers. He brackets these portraits with crude wooden frames that he has nailed together. The frames add a formality that lifts the work into a realm of intention and public communication. In the 1990s, Bissonnette began to work with a specialist in assisted communication— a controversial field but one that appears to have opened a window on his heartfelt desire to overcome the isolation of autism. From this collaboration came a sudden stream of poetry and personal revelations that portrayed a feeling human being cut off from others and struggling through his art to forge connections. With the aid of his facilitator, Bissonnette has "written": "TAPPING WELL OF SILENCE WITH PAINTING PERMITTED SONG OF HURT TO BE METED WITH CREATIVITY."

If Sacks is right that artists with autism never develop as acculturated, "real" artists do, then, like gods and monsters, they do not bear the burden of time and cannot tell us something essential about being human. They cannot inspire us with forms of celebration in the face of our progress

Larry Bissonnette
Untitled, ca. 1990s
Mixed media and
wood, 16 x 14"
Outsiders often repeat
imagery again and again,
but for Bissonnette, this fig-
ure has multiple referents.
Sometimes it serves as a
portrait of himself, and
sometimes it stands for
other people he knows.

toward oblivion. But this is misleading. Only modern art has explicitly assumed the tragic burden of isolated self-consciousness and a temporality that hurtles us forward into the unknown. Earlier art and most sacred art sees the world as more static, and human consciousness as only one of its elements. The fact that the "vision" and technique of artists with autism do not seem to change or expand in range or depth means that their relationship to the world is not changing. Is that relationship incomplete? Certainly. Is the self behind it incomplete, limited? Perhaps, but the self as expressed in art is not some discrete thing but only the gestures that embody it, the traces it leaves behind. The repertoire of gestures can be rich and varied or narrow and repetitive, but the validity of any gesture cannot be dismissed without a loss to our sense of what it means to be human and the ways that created forms can testify to the diversity of that experience.

In the Eye of the Beholder?

How is it possible to appreciate art that is apparently without precedent?
How can we understand objects that are unlike anything we have seen—
and in some cases strike us as deeply disturbing? The works discussed in
this book are truly orphaned, with no home in biography or art history.
How can we gain the confidence to adopt them? Little attention has been
focused on the criteria for recognizing or judging outsider art. In spite of a
general consensus about the value of certain works and the importance
of certain artists, opinions and prejudices still rule the field, and tastes are
fickle. We should not be deterred by all this. Consensus about what makes
for "good" or "beautiful" art has been dissolving in the West for at least two
centuries, and the trend accelerated with the rise of Pop and Conceptual
art in the 1960s. Audiences are constantly being challenged.

 In the end, the best way to evaluate outsider art is to look at a great deal of it
and then apply some of the same criteria we would apply to any mainstream
work of art that we take seriously or that moves us. On a broader plane, we can
also seek out some of the common characteristics of outsider and self-taught
art that might help us identify what we are looking at. These features can serve
as landmarks in unfamiliar territory, mitigating the initial strangeness and ori-
enting our vision. This chapter attempts to provide some general guidelines for
"interrogating" the works and then offers a map of the territory.

 The first step to appreciating outsider art—or any art, for that matter—
is to identify what kind of thing it is, whether drawing, painting, sculpture,

Ken Grimes
Throw the Switch? On Off,
1993, Acrylic on canvas,
30 x 40"
Autodidacts and outsiders
frequently gravitate to
science fiction because of
its totalizing and prophetic
tendencies, its lack of
nuance, and its tolerance
for withdrawal from
contemporary experience.

or collage, and then to ask how the materials are used and what effects they create. What strikes us about the work in the first place? Where does the artist seem to invest her or his energy? In line, color, geometry, surface texture, materials? In images, words, or graphic scrawl? In knotted twine, broken glass, chicken bones, or coral blocks? In terms of imagery, what visual elements occur and recur, and in what relation to each other? Does the imagery appear to be telling a story?

The work of Ken Grimes (b. 1947) provides a revealing example of the union of form, content, and effect. Grimes presents a minimalist science fiction. He paints exclusively in black and white, with simple forms and hand-lettered phrases. His theme, repeated in painting after painting, involves a vast system of control elaborated throughout the universe, especially in technology. His texts alternate between ominous questions, urgent warnings, and obscure explanations. Grimes's brilliance lies in finding just the right vehicle for his paranoia. The black ground of his paintings imitates the sky of deep space, with its spiral galactic forms. The white letters

of his messages suggest that the revelations come from the cosmos itself, from alien sources of knowledge and power. At the same time, they also call to mind an old-fashioned blackboard, with its chalk lessons that must be learned in order for us to graduate to a higher level of awareness.

A possible next step is to make appropriate comparisons based on the best mainstream work in the category, referencing both historical and current examples. This does not mean trying to pin down whether an artist such as Grimes might have been influenced by someone else's work, or trying to fit the artist into an insider pigeonhole. True outsiders are often inveterate borrowers but are rarely influenced by others, and they never hide their borrowing. Jonathan Lerman has made wonderful copies of paintings by Matisse, Modigliani, and Picasso, but he is not influenced stylistically by them. Comparisons between insiders and outsiders can reveal aspects of practice and talent that might not be obvious. Bill Traylor is an inventive draftsman, able to draw his way out of some tight corners, but the extent of his ingenuity is more apparent when he is viewed in the context of cartooning, with its demands for narrative and tight framing, rather than in the context of classical drawing.

The other important step in appreciation is to regard the work as a self-contained system of visual relations, asking such questions as: How do the elements work together in order to achieve an overall impression? Is the image discontinuous or fragmented? What are the work's primary symbols or recurrent motifs? How do they relate to other elements in the work that might help decode their meaning, organization, or the role they play within the work? What other works has the artist made, and how do they appear to be related? Do the visual themes or techniques stay the same, or do they change and perhaps evolve over time? A powerful example would be Emery Blagdon's healing machines. These constructions of wire, aluminum foil, and wood scraps were often hung on the walls or from the ceiling of his barn and have in some cases an ascending structure. They are not art as such but devices for gathering and directing energy. Yet Blagdon also painted simple

Bill Traylor
Untitled (Three Figures on
Red and Blue Houseboat),
1940s, Poster paint and
graphite on cardboard,
15x 13"
Contending with a restric-
tive frame, as all cartoonists
do, Traylor draws himself
into a corner—only to
escape by compressing the
figure at the top.

abstract paintings. How do the two kinds of work fit together? For one thing, the paintings always sit on the ground, at the base of the constructions. Their patterns are repetitive, organic, and mazelike. Writer and dealer Randall Morris has speculated that they serve as channeling devices to bring energy from its source into the wire structures. Suddenly a new set of relationships is suggested between organic beauty (the paintings), mechanical form (the wire constructions), and healing power. The totality of the work comes into view.

These kinds of questions should open many doors to the works. We will be better prepared to ask them, however, if we realize that we are dealing with an outsider or self-taught work and not something more central to tradition. We won't expect the work to harbor meanings or intentions that are not appropriate to it, especially in reference to other works of art. Are there general features of outsider and self-taught art that identify the genres and

provide clues about the intentions and achievements of the artists? In spite of decades of attempts by everyone from well-meaning psychiatrists to total-itarian censors to create visual dictionaries of unorthodox art forms, the sheer variety of the work defies categorizing. The first thing that strikes anyone about outsider and self-taught work is its unhistorical idiosyncrasy. Twenty works could be chosen from the *Collection de l'Art Brut,* the collection assembled by Jean Dubuffet, that appear to have absolutely nothing in common although they were made by people living at about the same period, in roughly the same geographic area, speaking the same language. Of course, the same might be said for art today in New York, but such pluralism in insider art is a recent development and very much a sign of the times.

The question of biography further complicates the attempt to identify outsider and self-taught art. In the current climate, the value or interest of a work is somehow heightened if the artist can be shown to have suffered, or fallen out of society. This can take the form of special pleading ("This artist was abused and worked only with wads of gum!") or exoticism ("This artist worked in a coal mine for forty years!"). In the case of an artist such as Jon Serl (1894–1993), it has been all too easy to let the colorful facts of his life obscure his unflagging commitment to painting. Nevertheless, biography can be useful in dividing outsiders from insiders and thinking about what actually happens when the work is gestating. The deliberate primitivism of much of the insider painting of the 1980s, for example, looks thinner, more self-conscious, and calculated with each passing year. We are tempted to say that the difference between the paintings of Sandro Chia (b. 1946) and the outsider Carlo Zinelli is one of duress and necessity. With Carlo, art is never a strategy or a response to an art-world trend. But it may be that Carlo is just more imaginative in the way he uses a limited repertoire of forms. Do we need to know his circumstances, that he was a World War II veteran whose psychic trauma forced him into a mental asylum, in order to come to that conclusion? Perhaps. A biography may not justify or explain our interest in a work, but it can add force to its impact and reveal the source of certain imagery.

Jon Serl
Untitled (Man in Hat), n.d.
Oil on board, 36 x 44½"
As a rule, self-taught
artists do not distort reality
but master only as much
technique as they need to
render what is significant,
as when Serl uses elastic,
undulating limbs to
convey motion.

Without attempting to specify what they mean (that depends on the context of individual works), we can identify some recurring features of self-taught and outsider art and some of the situations in which the works are often created. Any one of these features by itself might also characterize works of insider art, but taken together they form a profile of art beyond the fringe of the familiar.

The Call from Beyond

At the age of thirty-seven, Madge Gill (1882–1961), an English housewife who had been trying to contact the spirit world, began to draw. Her drawings proliferated, unfurling on bolts of calico fabric or decorating small note cards. "I felt I was definitely guided by an unseen force, though I could not say what its actual nature was," she remarked.[31] Gill's spiritualism and drawing went hand in hand, as if she had been selected by forces beyond the visible world to present what was communicated to her. William Edmonson, a resident of rural Tennessee, began to carve sculptures of

Joseph Yoakum
Mt. Shasta of Coast Range,
ca. 1964-68, Colored
pencil, watercolor, and
ink on paper, 18⅞ x 11⅞"
The hundreds of drawings
made by Yoakum constitute
an alternative map of the
world, one that recovers
the primordial force of
undiscovered but intensely
imagined landscapes.

great simplicity and power, although he had never had any training or pre-vious interest. He did it, he said, because God commanded him to make a tombstone and showed him a vision of it. After what Chicago resident Joseph Yoakum (1890–1972) claimed were years of traveling around the world, to locations as distant as Siberia and China, at the age of perhaps seventy-two he had a dream in which God told him to pick up a pen and a piece of paper and draw. He spent much of his last ten years rendering an extensive visual catalogue of remembered—or imagined—landscapes. While working in a coal mine, at the age of thirty-five, Augustin Lesage heard a voice say to him that someday he would be a painter. He began to draw soon thereafter and produced more than eight hundred canvases, some as large as 100 square feet. He insisted that all his drawings and paintings were produced with the instruction of spirit guides.

For outsider artists, and for many self-taught artists, the decision to begin making art comes as suddenly and arbitrarily as an act of God. Often it is associated with psychic events and behaviors that cut the individual off from routine intercourse with the world—symptoms that provoke institutionalization, crimes that force incarceration, personal loss or separation that shatters a fragile stability, even simple retirement that disrupts routine and throws people back on their inner resources. Edward Leedskalnin began to create his Coral Castle, a compound of buildings and stairways made entirely of coral that he quarried and cut himself, after he was jilted by a prospective bride. Sometimes the reverse is also the case. Born with Down's syndrome and deaf, Judith Scott (b. 1943) was warehoused in a mental institution for nearly forty years. It was only after her sister managed to secure her release that she began to create wrapped works that resemble Inca mummy bundles—which she has done without letup ever since.

With such eruptive beginnings, the "careers" of most outsider artists do not display the conventional pattern of initiation, growth, and maturity evident with most insider artists. Many self-taught and outsider artists do

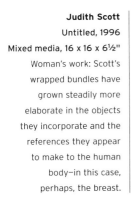

Judith Scott
Untitled, 1996
Mixed media, 16 x 16 x 6½"
Woman's work: Scott's wrapped bundles have grown steadily more elaborate in the objects they incorporate and the references they appear to make to the human body—in this case, perhaps, the breast.

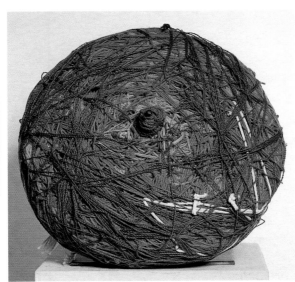

not begin working until late in life (or until their outward circumstances change) because they do not have the opportunity and time or have never experienced an occasion that triggered creativity. Institutional or community art programs have provided that occasion for many artists. Freddie Brice (b. 1920–d. 1990s) might never have begun painting without the introduction to art provided by artists working at a seniors center in New York. And just as they may commence without preamble or apprenticeship, outsider artists can suddenly fall silent, without any concern for livelihood or past production, especially if the conditions that provoked their work disappear. Simon Rodia (1879–1965), the untaught sculptor who single-handedly built the celebrated Watts Tower in Los Angeles, stopped working after he completed the multiyear project and disappeared.

Personifying or objectifying the impulse to create as a call from beyond is a way of putting into words the experience of inspiration, which cannot

Freddie Brice
Brice Bear, 1990
Acrylic on plywood, 48 x 42"
Some of the most prominent self-taught artists, including Brice, display what might be called the Matisse factor, an ability to reduce complex forms and groupings to their graphic essence.

be rationally fathomed or directly articulated. And always, lying just beyond the alien experience of inspiration, is the compulsion to prophesy, to speak or make images in a divine language impervious to the corruptions of ordinary speech. Such a compelling encounter with otherness removes the burden of responsibility for submitting to a creative prompting that may not be socially acceptable. Under the powerful suasion of seemingly external forces, anything becomes possible and no creative act needs justification. Outsiders and many self-taught artists confront us with the stark fact that the sources of art are fundamentally unconscious and impersonal, however individual the forms creativity takes.

The Demise of Time

In a sense, every artwork becomes "timeless" as soon it is created and stands independent of its maker, but there is a sense in which outsider and some self-taught art is severed from history even before it comes into being. When Martin Ramirez, Henry Darger, or Aloïse Corbaz (1886–1964) included found images in their work, they did not refer to any specific sense of tradition or to the historical situation (past/present) of the images. Nor did they care about the style of the imagery or that it was usually a second-hand reproduction. Their primary concern was the visual content of the imagery and what it suggested to them emotionally and formally. The content might have had a historical appeal, might even have suggested a vast scheme of history, but the artistic past exerted no pressure through these images. Instead, the past offered a free-floating repertoire of images to be used at will, regardless of their origin. Outsider artists triumph over time because time offers no measure or resistance, only visual material to aid their work.

By the same token, the art of many outsiders tends to exist in a present tense. It rarely deals with historical or objective events as such, or with the panorama of the social and natural worlds. When it is narrative and does confront the artist's own past, as with Ramirez, the scenes tend to unfold in

Aloïse Corbaz
Untitled (page from a note-
book of 24 pages), n.d.
Colored pencil on paper,
25¾ x 9½"
A tutor for the children of
Kaiser Wilhelm II until she
became infatuated with the
Kaiser and her mental condi-
tion deteriorated, Corbaz
seems to have "used" her
illness to produce a vast
body of drawings.

stylized realms divorced from the ordinary and everyday. The narratives are
generally mythic or allegorical, presenting a play of symbols in the guise of
a story that unfolds in an open-ended time frame. This is the case with the
art of Darger and Adolf Wölfli, both of whom conceived their life's work as
storytelling. Wölfli, especially, sought to present not a temporal but a uni-
versal or timeless history, one that extended from his earthly childhood
into the eternal cosmos, where figures from his past were transformed into
gods and goddesses. His role in the process of narration changed as his
vision grew in scope. He eventually imagined himself as a holy figure, a
kind of prophet, and called himself Saint Adolf.

Self-taught artists, on the other hand, often immerse themselves in time—in the present and in history. Sam Doyle (1906–1985), who lived on an island in South Carolina, painted not only the people around him but also historical episodes and tributes to figures such as Elvis Presley and Abraham Lincoln. And yet, what is compelling about his portraits is that all the figures are painted with the same degree of presence and immediacy, overturning the sense that past things are past. Even more complex is the case of self-taught painter William Hawkins. Hawkins often used collage elements in his paintings, taking them from many sources including magazines and newspapers. He seems the classic outsider in ignoring all but the most obvious visual content of the images. In a work such as Untitled (Praying Mantis) however, he appears fully aware of the pop-cultural nature of the imagery. Indeed, it may be what attracted him in the first place.

Hawkins is important for another reason. Many self-taught and outsider artists—especially those with autism—seem not to develop as artists. Once more, they appear to leap outside of time. That is, they may shift from

William Hawkins
Untitled (Praying Mantis), 1989, Enamel and paper on Masonite, 48 x 39½"
The connections between the images Hawkins borrowed and those he painted is not always obvious, but the dominating force of his painting unifies both.

subject to subject, but their visual approaches and ability to render seem to arrive more or less full blown and remain fixed. The artists may solve problems for each new object or image but rarely learn from past struggles. There is nothing comparable in self-taught art to, say, Picasso's radical shifts from Postimpressionism to Cubism to neoclassical forms. Nevertheless, the narrow view of self-taught art may be the partial result of a lack of critical attention and the absence of anything like conventional careers for most of these artists. A closer look at Hawkins's work, for instance, reveals important changes over time, especially in his bordering of images. His sense of the decorative becomes more dramatic as the framing takes on a patterned life of its own, transformed into a kind of advertisement for the image rather than a mere repetition of the painting's basic color scheme. Unlike most outsiders, Hawkins was concerned with creating beauty, and he focused on pattern and color because that was primarily where beauty resided.

Flatland

When critic Clement Greenberg declared in 1965 that the central idea of modern painting was to reassert the flatness of the medium, he was implying a broader truth. All the ways artists have chosen to represent the world are based on conventions. None of them is natural, least of all three-dimensional representation. The perfection of perspective in Western painting evolved over hundreds of years, gaining impetus from an increasingly secular worldview. Most outsider and self-taught artists ignore this naturalism without a thought, as easily as any modern abstract painter, even though they rarely paint in pure abstractions. Finding ourselves in Flatland is one way we know that we have encountered autodidactic work.

There are some obvious reasons for this minimal topography. The first is that realistic, perspectival rendering is a difficult skill to learn, and most self-taught artists never master it. They seldom get beyond adapting what they see or imagine to two dimensions. They achieve depth only by accident or luck. Even an artist as gifted as Gayleen Aiken, who could render

perspective as a five-year-old, cannot consistently translate her sophisti-cated architectural sense to outdoor scenes. In those settings, she incorpo-rates a different approach to space. Likewise, Chris Murray (b. 1960), cannot extend his sense of the city's gridded, rectangular repetitions into the geometry of three dimensions. The resulting flatness and verticality of his images emphasize the city's dense compression. Jessica Park appears to offer a striking exception. She has the ability to render oblique perspectives, such as an overhead view of the George Washington Bridge, in the same style that also characterizes her flat, colorful, precise images of houses and buildings. Yet the meticulous geometry of her images is also oddly unseen, as though it has been constructed from a program. The overall effect is dizzying, providing and denying perspective at the same time.

Describing these approaches as a failure to master convention is perhaps misleading. These artists learn only so much as they need to in order to present what is psychically relevant, visually pleasurable, or symbolically appropriate. Darger was far more interested in horizontal organization

Chris Murray
New York City Manhattan East 68 and Park, 2001
Acrylic, graphite, and pen on paper, 45 x 35"
Flatland 1: Murray's fidelity to what he sees runs up against his ability to render the complicated geometry of urban space, so he devises a two-dimensional alternative.

along narrative lines than in fully realized, three-dimensionally correct land-scapes, but he knew exactly what to do with the backdrops he created, staging one apocalyptic sky after another, enhanced by a dramatic use of color. Ramirez's sense of space is primitive in conventional terms, flat and vertical. Although he forces everything onto the same plane, skewing the proportions of the elements, he uses this limitation to emphasize the vortexlike power of his tunnel imagery and the hierarchical, perhaps sacred, position of central figures such as animals, cowboys, and priests. In the case of outsiders such as Park, Corbaz, and the Austrian Johann Fischer (1926–1996), the artist shows no fidelity to a preexisting reality. These artists have no interest in mastering the conventions that would be necessary to achieve a goal they do not seek. Their primary experience is the encounter between a hand driven by imagination and the flat surface. Art becomes an enactment, not a transcription. The depth and dimensions of the image arise entirely in the patterns and relations of the figures that fill the space.

Two other common aspects of Flatland are symmetry and hierarchical organization. Many outsider and some self-taught drawings present elabo-

Martin Ramirez
Untitled, detail, ca. 1950s
Mixed media, colored pen-cil, graphite, and crayon on paper, 24 x 90¼"
Flatland 2: Ramirez's is not a true Flatland, for he marshals techniques for rendering depth and per-spective, but he subsumes them in pattern and emblematic organization.

Johann Fischer
Unser Vienna [Our Vienna],
1994, Graphite and colored
pencil on paper, 12¼ x 17¼"
In Fischer's work, text and
image are tightly woven
together visually but have
little interrelationship
in terms of content.

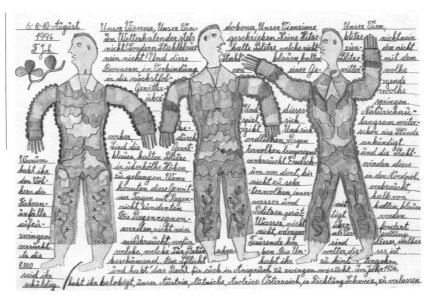

rate forms that either attempt symmetry along a vertical axis or are elabo-
rately and carefully arranged. Fundamental to the capacity of human beings
to recognize each other, bilateral symmetry is a way of organizing visual
experience in the work of an artist such as Minnie Evans (1892–1987). In
the work of Mexican artist Consuelo (Chelo) Amezcua (1903–1975), it is
subsumed by a need to connect elements more organically. In her work,
geometric decorative and architectural forms butt up against and overlap
representational elements framed in flowing, organic shapes—usually
visionary figures around whom the work is organized. The radical conjunc-
tion of flowing and geometric forms is common in outsider art, as if the
artist vacillated between two fundamental types of gesture and allowed
each one to take over in turn until the sheet is filled. Other influences may
be at work in Amezcua's "filigree art," as she called it, especially local metal-
work and religious art. Her impulse is to convey majesty and authority, best
confirmed by a structure that is flat, vertical, and hierarchic, but also fluid
and sweeping. Is the vision the artist seeks to convey one of an ordered
universe, in which all elements can be related to one another? Or does the

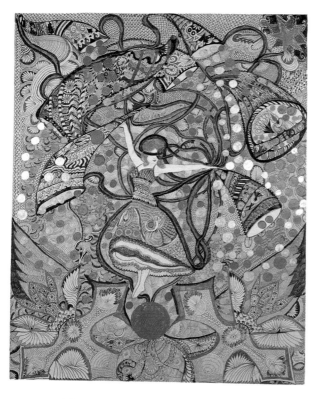

Consuelo (Chelo) Amezcua
Abundance the Blind, 1966
Ink on mat board, 27 x 23½"
Amezcua's paintings are
allegories, usually ordered
around a central figure.
Here the blindfolded figure
of Abundance randomly
bestows her gifts, symbol-
ized by the profusion of
pattern in the image itself.

process of drawing actually bring the vision into being, that is, the artist does not see or imagine a world until the flatness of the medium and the activity of drawing begin to call it forth and promote their own elaboration? It is from the art that order emerges, and not vice versa.

No More Masterpieces

Artists always see their own art differently from the way audiences see it. The works they appreciate most are often different from the ones critics praise. But with outsider artists and with some self-taught artists, this problem never arises because the artists themselves seem often to have no sense of quality or make no judgments when it comes to their own work. They are capable of producing astonishing pieces and inept ones back to back—at least in the eyes of critics and collectors. In the more extreme cases, they do not make

any revisions as they work, although they may simply stop working on a piece and put it aside, and they do not "edit" bodies of their work. Dwight Mackintosh (1906–1999) would work intensely on drawing after drawing, sometimes for entire nights. But when the drawings were finished, he would put them aside without a second thought. In a way, these artists resemble photographers, who might shoot many rolls of film of a particular subject. But photographers seek the single acceptable image in a hundred frames. Outsiders would keep them all—or get rid of them all.

This is a long way of saying that outsiders often do not regard their productions aesthetically, as singular, self-sufficient embodiments of their vision or even as their "own" creations. For most outsiders, the created object is a means to another end or the by-product of a process of inner equilibration. So Carlo Zinelli can repeat his E.T.-like humanoid forms in a variety of settings and organizations, with a wide range of colors. Critics prefer the works with rich color schemes, and elaborately complicated images, with their unsettling repetitiveness and motifs of incarceration. But his simple, hasty, black-and-white images reveal his fundamental preoccupation with the human form, in all its vulnerability and nakedness.

Dwight Mackintosh
Untitled, 1981, Graphite and tempera on paper, 25⅛ x 37¾"
At the edge of drawing: Mackintosh's drawing and writing unwind from some inner calligraphic spool, his lines entangling to form images, often repetitive but never exactly the same.

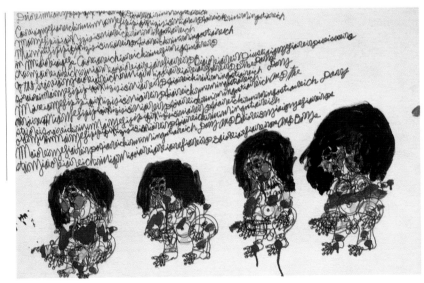

In general, outsiders are not interested in having their work judged or appreciated as such (again, there are exceptions), but they often seek its acknowledgment as a means of affirming what can otherwise be a very tenuous connection with other people and the world at large. Although he rarely spoke in the asylum where he was confined, Ramirez was concerned that his drawings not be lost or confiscated; he may have given away many of them to other inmates and to the psychologist who first collected his work, Dr. Tarmo Pasto. While we call outsider art intensely private and personal, there is a way in which the opposite is true. If it is addressed to the outside world, it is almost never addressed in a personal sense to another individual or a specific audience, what the novelist Stendhal called "the happy few." Rather, the address is general because the vision and communication are intended for everyone and no one, for an entire world of others among whom the artists exist, others they cannot engage yet to whom they must direct the knowledge of their discoveries.

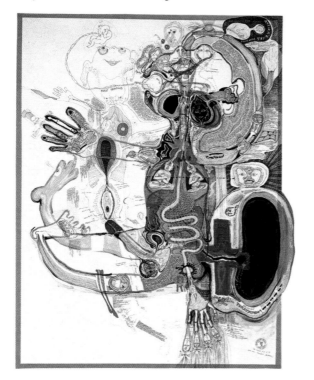

Lubos Plny (b. 1961)
Untitled, 2001
Colored ink and gouache,
blood, stabylo, golden
paint on paper, 35⅝ x 27¼"
Plny opens up the human
body like an X ray to provide
a symbolic investigation of
its organs and processes,
especially birth.

Robert Gove (b. 1934)
Untitled, ca. 1995
Mixed media on paper,
12 x 18"
Outside the lines: Some
outsiders treat elements
such as color and line as
independent entities, creat-
ing palimpsests instead of
unified images.

In the end, audiences cannot avoid the question of whether in the face of the most solitary, disenfranchised works, it makes any sense at all to apply terms such as "quality," "mastery," or "beauty." Western audiences have managed to bring in under an aesthetic umbrella (as "art") such objects as Mayan stone carvings and Kongo power figures, whose original context was ceremonial and whose principles of form have little to do with Western aesthetic norms. They have clearly done the same kind of appropriating with the so-called art of the insane. Is this appropriation legitimate? Without a doubt, we can identify works of great suggestiveness and impact based on *our* standards and experience, but can we demand that all such work "stand on its own," in some vast imaginary museum of timeless "masterpieces," free of any consideration of its origin and purpose? Can we look at a drawing by Mackintosh, which seems to exist at the very edge of representation, in the same way we look at one by Cézanne? The drawings themselves won't allow us to do that. What we call outsider art is first and foremost a by-product of the artists' encounter with their own psychic experiences, scarcely mediated by convention, culture, or community. Our appreciation of the art cannot help being colored by our recognition of the urgency, and occasionally the desperation, of the process.

What is most impressive about outsider and self-taught art is the artists' ability to turn limitation to advantage, leap over barriers of their own ineptitude, and indulge to a point beyond excess the things that they can do.

Sex

We live in a visually permissive society. Depictions that have been historically taboo in the West, including explicit sexual acts, have become commonplace, and, as noted in chapter two, transgression constitutes a kind of yardstick of contemporary artistic progressiveness and an avenue to reward. Images that once were confined to a subculture or an underground—or the artist's notebook—are now displayed, and in some sense neutralized, for public consumption. In this context, it could be argued that artists have always practiced at least two forms of repression when it comes to sex.

In the first place, as mentioned above, according to Freudian psychological theory, art-making itself involves a deflection or sublimation of primal

Johann Korec
Untitled, 1992
Watercolor and ink
on paper, 8½ x 5¾"
The joy of sex 1: Korec's
perpetual subject is the
pleasure and necessity
of making love with his
girlfriend.

Ele D'Artagnan
Guten Morgan Welt
[Good Morning World], 1979
Colored pencil and
marker on paper, 9½ x 13"
The joy of sex 2: An actor in
several of Federico Fellini's
films before he began
to suffer from mental insta-
bility, D'Artagnan produced
priapic psychedelic drawings
celebrating the phallus.

sexual urges that cannot be realized directly and so seek a symbolic resolu-
tion. Thus, in art, sex is everywhere and nowhere, a kind of atmosphere or
white noise. Since it may not show up explicitly, uncovering the visual sym-
bols of sexual motivation in a work of art can become an intellectual parlor
game. At another level, irrespective of psychological theory, insider artists,
as well as most self-taught artists, inevitably practice a form of self-censor-
ship. They are born into a dominant culture, and no matter how iconoclas-
tic they may be, the society broadly shapes their artistic practice by a shared
sense of what is meaningful and possible. Even when the subject is explic-
itly sexual, whether it is the rape of the Sabine women or Leda and the
swan, cultural norms, in a wider sense, limit the treatment. What falls out-
side these unwritten sanctions is considered pornographic, and certain
artists have explored that territory energetically. In modern and contempo-
rary art particularly, they have frequently sought to cross the barriers of
inhibition and erase the borders of the acceptable.

For outsiders, however, pornography as such does not exist because the
superficial cultural censors do not exist. The force of sexuality is a fact they

have no reason to deny or gloss over in the name of good taste. When sex comes into the picture, it can be naively blunt or disturbingly angry and violent. Johann Korec (b. 1937), another of the Gugging Clinic artists, returns repeatedly to the subject of having sexual relations with his girl-friend, Brigitte, and the image of the two of them in bed becomes a kind of chant of happiness. Korec does not seem to be aware that sex is a commonplace event. Nor does the self-taught Italian artist Ele D'Artagnan (1911–1987), whose priapic pen drawings celebrate the phallus over and over again. In the opposite vein, Dwight Mackintosh often drew figures with erect penises but seems not to have accorded this obvious fact any special status in the vast output of his work.

Yet explicit sexuality tends to appear far less frequently in outsider art than in insider art. Again, outsiders do not attack norms per se, so the contemporary cultural need to risk explicitness is absent. At a deeper level,

Royal Robertson
God of Host Cursed, ca. 1978
Colored pencil and gouache on paper, 24 x 18"
The torment of sex: Many of Robertson's works are fulminations against female sexuality and betrayal.

Henry Darger
At Calmanrina, side A, detail, ca. 1950, Watercolor, graphite, and carbon tracings on paper, 8¼ x 35¾" When Darger's imagery turns violent, he departs from tracing and draws acts of strangulation, for which he has no visual models.

however, the internal mechanisms of repression may be stronger and the sense of sexuality as an unbidden, alien force can be far more intense, prompting violent deflections and a shattering of the body's image. Royal Robertson (1936–1997) began making art after his wife left him. This prompted an outpouring of signs and explicit imagery denouncing sexuality and women. Their prominent display soon brought Robertson into conflict with his neighbors. As far as we know, Henry Darger was never able to progress to any form of sexual engagement; the world he created was one of ambivalent projections. His adult males are sadistic killers, but the nubile Vivian girls also have male equipment below the belt, and that makes them a target of his own rage and desire. While he sees the girls as victims and innocents, he spends much of his energy detailing the violence committed against them, and the only times he appears actually to draw, as opposed to his usual modified tracing, is when he depicts the awkward postures of strangulated girls.

In outsider art, although sex may not be explicit, it is so pervasive that the libidinal body, as critic Allen Weiss terms it,[32] becomes itself an organizing system, projected onto everything. In the architectural drawings of Achilles Rizzoli (1896–1981), who for many years shared a bedroom with

his mother and was never known to have had sexual relations, sex is mani-
fest in both literal and abstract configurations. It is named explicitly ("phal-
lism") and by its obsessive opposite ("purity," "perpetual virginity"), and
almost every image echoes it in the towered, upthrusting structures of
Rizzoli's ideal city. Sex is elevated to a cosmic or spiritual reality that is
finally the foundation of form and meaning.

Words in Commotion

Paul Klee insisted that writing and representing were identical, and the
work of outsider artists and many self-taught artists embodies this insight.
In examining Western art, we tend to separate writing and drawing, assum-
ing that writing is somehow transparent communication, purely a means to
an end, while drawing and painting are embodiments, denser presences.
They communicate, but more opaquely. Yet religious art, whether of the
East or West, has never made such separations, and that fact may illuminate
the practice of some self-taught artists, especially those raised in a culture
of proselytizing Christianity. Outsiders often see writing and drawing as
indistinguishable aspects of a single, unitary process of formal generation
and organization. They frequently use numbers in a similar way. An imme-
diate but probably mistaken conclusion is that outsiders are attempting to
communicate a univocal message, albeit in a language only they can under-
stand. The reality is far more intriguing.

First and foremost, letters are abstract visual elements, every bit as figura-
tive as imagery, and the physical process of writing can be intense and
engrossing. Insider artists from Picasso to Cy Twombly (b. 1928) have played
on the character of inscription, but outsiders enact orthography as a central
compositional reality. Jonathan Lerman's signature becomes a distinct and
multifaceted graphic element in his drawings, employed a dozen different
ways. The unintelligible writing that often crowds the images in the draw-
ings of Dwight Mackintosh seems to curl out of the involuted details of his
figures. Wölfli's lettering is the most spectacular example, incorporating

Achilles Rizzoli

The Primal Glimse [sic] *at Forty*, 1938, Ink on rag paper, 64 x 26 ⅝"

Rizzoli represented people he knew—and, in this rare case, an event—symbolically, as monumental architectural constructions, the majority of which involve towers with distinctly phallic characteristics.

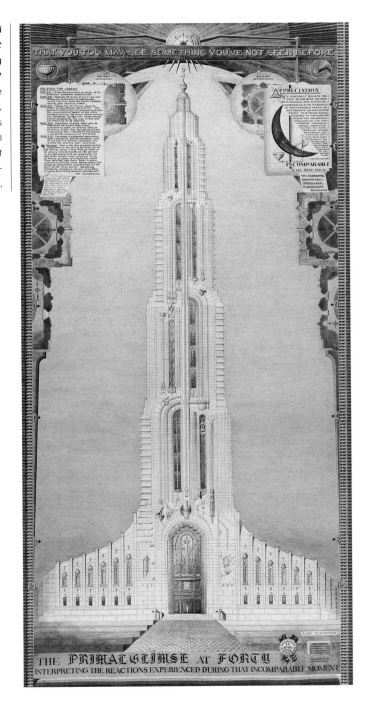

German Gothic characters, freehand script, musical notation, handwriting circles and swirls, and invented graphological characters. Some of Wölfli's writing is explanatory and narrative, some poetic, some mere lists or strings of words, and some only repeated linear patterns. The script follows the contours of the visual imagery in mesmerizing ways, winding in and out among the figural motifs and cascading down the contours of collaged picture-elements.

It is clear that we are not dealing with a "system" of coded signs, for which there exists a master key or logic, as with the visionary poetry of William Blake, for instance, which is highly programmatic. In most but not all cases, explanations by outsiders of their visual systems add yet other possible structures of significance without actually providing a dictionary to the visual language. Wölfli's system, like that of most outsiders, is spontaneous and flexible, even in its repetitions. It can move from one seeming realm to another in a single line, undercutting the sense that the artist is attempting to share a single "meaning." It seems clear from his own explanations that he is trying to communicate a

Adolf Wölfli
Untitled (Campbell's Tomato Soup), 1929
Graphite, colored pencil, and collage on newsprint, 27 5/8 x 19 3/4"
Words as images: In Wölfli's later drawings, script plays a dominant role, often threatening to overwhelm the visual organization of the images. Detail of script below right.

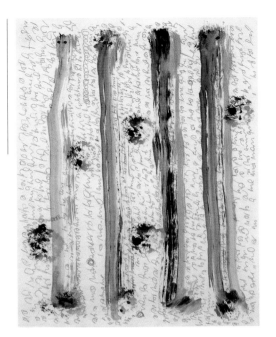

J. B. Murray
Untitled, n.d., Mixed
media on paper, 14 x 10³⁄₈"
In Murray's work, language
becomes pure visual
abstraction, with a
significance that can be
grasped only by spiritual
engagement.

meaningful vision, and he often returns to certain key narrative figures and characters, just as he does to certain visual elements, but the meaning is the experience that comes to Wölfli as he organizes and executes his drawings. It spins out of itself toward an encompassing expression that is beyond language.

Of all the outsider artists, J. B. Murray (1908–1988) shows us the purest form of language and text as image. A Georgia farmworker who could not read or write, Murray had a religious experience and began to draw, or rather, to make calligraphic works containing messages he said he had received from God. He would read his messages aloud by looking at his drawings through a bottle of "holy water." The drawings, in columns of figurative images and script, have fluid, indistinct contours that feel as if they have indeed been glimpsed through a watery medium. Although spontaneous, they are meticulous and often carefully gridded or divided into different zones of abstraction, suggesting yet another level of meaning. The "letters" are themselves gestural abstractions, almost but not quite ideograms, and finally indecipherable. Like so much of outsider art, the organization of

the drawings promises a meaningful scheme of communication that the work itself withholds. It suspends us, the "readers," between interpretation and revelation. Murray, Wölfli, and, in a different way, Rizzoli, seem to be attempting to renovate language, to discover through visual manipulation and recombination new words, orthographies, syntactic patterns, and even new sounds. It goes without saying that such a renovated language would manifest a significance beyond ordinary powers of comprehension. Renovated language can be grasped only by a renovated mind.

There is another important way in which self-taught artists use language with powerful impact—in scriptural and didactic signs. Here the intent to communicate is clear, the sources of inspiration near at hand. The audience for this communication may not, however, be obvious or certain. Both Howard Finster (1916–2001) and Jessie Howard (1885–1983) present themselves and their projects in biblical terms, buttressed by scriptural quotation. Howard used the sign as a way to air his views on a host of matters, from taxes to the Apocalypse. His immediate audience was his surrounding community, which often took exception to his haranguing messages. Like a true prophet, however, he seems to have been addressing not just his neighbors or an oppressive government but also everyone with eyes and ears, and beyond them a celestial community, the ultimate public forum. This form of testifying is common to folk art throughout the southern United States. Finster was himself a preacher who in 1976 had a vision that God commanded him to "make sacred art." Everything he undertook, including paintings, sculptures, the objects in his Paradise Garden, and the "thought cards" he wrote out, became a delivery system for his Bible-inspired visions. Language performs a complex role in these signs, linking the sacred (and inner) world and the outer world of images. Finster's world of images is amazingly diverse, ranging from ordinary experience to art-historical insights to cosmological speculations. Inspired by events and images, as any visual artist is, Finster had no true vision until language seized that inspiration and elevated it to a form of public testimony. His works are manifestations at least as much as they are art.

Howard Finster
Untitled, 1978
Oil on Masonite,
34¼ x 18"
The peril of idolatry:
Finster's art bears the
burden of his messages,
but his imagery has
a life of its own.

Repetition and "Obsession"

Repetitive visual patterns, intricate detail lavished on trivial visual elements until a sheet of paper becomes an impenetrable field, words and phrases incorporated over and over again like mantras—these are some of the elements of outsider art most familiar to the public. They are lumped together under the term "obsession." But surely Picasso was in the grip of an obsession that would not allow him to stop making images, and Matisse was as well, painting as an invalid from his bed using a long pole with an attached brush. The same can be said for contemporary artist Steve di Benedetto (b. 1958), for example, who for a number of years has made images almost exclusively of helicopters, or the photographer Garry Winogrand (1928–1984), who shot thousands of rolls of film he would never print or even look at more than once. Obsession is the occupational hazard of all artists, who would rather do what they do than anything else, or, at least, cannot stop doing this one thing regardless of what they desire.

Nevertheless, the obsessions of the outsider are of a different order. When an outsider artist hits upon a vein of imagery, he or she is content to mine it, with variations, almost indefinitely. So Heinrich Reisenbauer (b. 1938), an artist of the Gugging Clinic, produces drawings that contain a single image, usually of an ordinary object such as a chair or an umbrella, repeated multiple times in ordered rows. His work never deviates, and its unsettling charm lies in its repetitive simplicity. Wölfli reverted to certain images throughout his career: the serpent, the bird, panda-eyed or masked circular faces, often adorned with crosses. In a different vein, Donald Mitchell (b. 1951) draws the same human figure, resembling the stackable 1950s wooden toy called Bill Ding. He repeats the figures in rows and stacks them on top of each other, overlapping them until he runs out of space, yet it is not clear that the figures are meant to relate to each other. We call the art obsessive because it contradicts our notions of self-aware-ness and artistic progression. At any point, the work seems to express the same preoccupations in the same forms as when the artist began, as if the entire career were completed within an unbreakable circle. Art making seems as much a trap as a liberation.

Donald Mitchell
Untitled, 1999, Ink on paper, 22 x 33"
Piling on: Mitchell under-mines the notion of a drawing as a discrete formal object by piling the same figure on, over, and around itself in a series of discontinuous actions.

Augustin Lesage
Compositions symboliques sur les vestiges d'un grand passe [Symbolic Composition on the Vestiges of a Great Pass], 1935
Oil on canvas, 48 x 35¾"
Lesage's "architectures" grow spontaneously toward order rather than following a prearranged plan.

Obsession also shows itself in the elaboration of detail. Many contemporary artists might be indicted for obsessiveness on this score. The recent portraits of Chuck Close, for example, are constructed entirely of small ellipses of paint in different color combinations, organized in grids to compose the faces. Yet the difference between such a painstaking program and the detailed worlds of Augustin Lesage, Madge Gill, or Johan Garber (b. 1947) is striking. In Close's paintings, the tiny elements are orchestrated into a distinct, recognizable form, a unifying gestalt, as the psychologists call it. The outcome of the work is prescribed, so to speak. In the work of these other artists, although there appears to be a subordinating principle or a dominant formal image, it is often subsumed or subverted in passages of pure pattern, indulged apparently for their own sake. Even those elements that do obviously belong to the overall subject—windows, for instance, or the fabric of a dress—are repeated or detailed in uncontrolled

profusion. Lesage provides a fascinating example because his paintings seem to have been done with no prior plan. Rather, they grew spontaneously under the direction of his spirit guides. They appear to have an overall shape, however improvised, but like so much outsider art, they are impossible to comprehend in a single instant perception. The eye is forced to travel across them and is always in danger of losing its way and drowning in detail. The artist demonstrates his obsessiveness not merely in the act of making such images or in filling up the space, but in devoting equal attention to each thing without regard to its relation to other things. The sameness of treatment masks a radical discontinuity within the images themselves, as if nothing bound the work together beyond the artist's continuous preoccupation with each instant of creation.

The Gift of Materials

Simon Sparrow (1925–2003), a self-taught artist from Madison, Wisconsin, created mosaics out of whatever he could find that reflected light, including chips of glass and stones. This material suggested to him the opulence of times past, an opulence he felt art should possess. For inspiration, William Hawkins collected imagery from newspapers and magazines, which he copied or incorporated into his paintings. He kept his precious scraps in a suitcase and often sifted through them, looking for something in his collection to "give him a gift." Bessie Harvey (1929–1994) found her ideal material in gnarled tree roots, from which she fashioned sculptures that resemble African power figures or fetishes. As Harvey remarked in an interview, "They talk. We talk when I'm making them; we talk when I'm not making them. Sometimes I just pick up a piece of wood with nothing on it and I know then what it's going to be, and I know it right then, and I start talking to that piece of wood before I touch it, before I do anything to it, because I already know it's something."[33]

The dominant tendency of modern and contemporary artists has been to incorporate ever more diverse materials into their work, from a widening

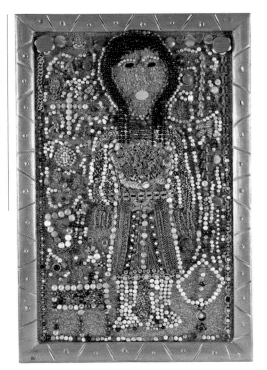

array of sources. Outsiders tend to push this heterogeneity to extreme levels, even by today's standards. Materials give every artist a gift, but for insiders, this process of incorporating unconsecrated, "unartistic" material has usually been a historically self-conscious act. The self-consciousness is best symbolized by Duchamp's "readymades," ordinary objects staged as art, and Robert Rauschenberg's "combine" paintings, which incorporated found objects, including Coke bottles and stuffed animals, into a painted field. For outsiders and self-taught artists, however, the choice of materials often depends simply on what is available. Early on, Martin Ramirez could obtain only pencils and paper bags, which he glued together with his own spittle. But even if the initial choice is fortuitous, the persistence in a medium often becomes rigorous. This is a matter of fit and feel, of course, as it might be for any artist. But given the outsider's agenda of organizing and reconciling extreme experiences, materials can become charged with an urgent energy, to such a degree

Bessie Harvey
Cross Bearers, 1993
Mixed media, 68 x 60 x 27"
The lure of materials 2:
Harvey's anthropomorphiz-
ing root art treats nature
as metaphor and takes the
metaphor literally—as does
all magical thinking.

that it almost appears as if the materials themselves prompt the art making.
When James Hampton sought a noble material for his *Throne of the Third
Heaven of the Nations Millennium General Assembly,* which he built in a
garage in Washington, D.C., he covered his entire sculpture with metal foil.
Without this material, the throne might never have been created or even
imagined. Likewise, steel and scrap iron have inspired Billy Tripp (b. 1955)
to construct his *Mind Field,* an immense and expanding abstract structure in
Tennessee. In some cases, the materials can carry primordial or preconscious
associations, as when Judith Scott wraps dolls or objects such as broken fans
in bundles of twine—a nesting and swaddling process that touches the earli-
est realms of infant experience, even as it suggests a process of concealment.

As noted below, outsiders can also be omnivorous, incorporating every-
thing into their visual systems. Bodan Litnianski (b. 1913) has created a
phantasmagoria of junk, which he calls the Garden of Shells. Its sponta-
neous architecture of columns and walls is made entirely of discarded

objects. For outsiders, the impulse to hoard and collect is aligned with the impulse to organize and display, as a means of bringing the outer world and the inner world into congruence. In the 1920s and 1930s, the insider artist Kurt Schwitters (1887–1948) engaged in a similar project called *Merzbau*, an architectural construction, based on found materials, that grew and grew. Destroyed by war and interrupted by exile, the *Merzbau* was rebuilt three times, and Schwitters was still working on it at the time he died. He wrote: "In *Merz* house I see the cathedral: *the* cathedral. Not as a church, no, this is art as a truly spiritual expression of the force that raises us up to the unthinkable: absolute art. This cathedral cannot be used. Its interior is so filled with wheels, there is no room for people."[34] For Schwitters, as for many outsiders and self-taught artists, the detritus of the everyday world promised the gift of an absolute art, an art that would not merely symbolize a great unity but confirm it, indeed bring it into being. The source of that unity was beauty, the agent was human imagination.

Billy Tripp
The Mind Field,
Begun 1989 (ongoing)
Scrap metal,
various dimensions
The lure of materials:
For many self-taught
assemblage artists, scrap
metal seems to demand
monumentality.

Hedwig Wilms (1874-1915)
Untitled (Tray with Coffee
Pot and Milk Jug), n.d.
Cotton yarn, 8⅞ x 12 x 6½"
The radical collision of mate-
rial and object anticipates
the juxtapositions of the fur
teacup by Surrealist Meret
Oppenheim (1913-1985)
and sculptures by Claes
Oldenburg (b. 1929).

Totalizing Vision

The output is staggering: 25,000 densely worked, complex pages and
nearly 3,300 drawings and collages in little more than three decades—the
output of Adolf Wölfli dwarfs even that of the indefatigable Picasso and
Matisse. So, too, does that of Henry Darger, who produced not only an
illustrated epic of some 15,000 pages but also a 5,000-page journal detail-
ing weather patterns. Although still a teenager, Jonathan Lerman has
already produced hundreds of drawings at breakneck pace. In a different
vein, the Frenchman Ferdinand Cheval, the American Howard Finster,
and Nek Chand, of northern India, spent most of their late adulthood
creating elaborate environments.

Even more striking than the prodigious output and energy of these artists
are the ambition and scope of their projects. They attempted to create visual
worlds in which all the significant features of their imaginative life could
find a place. For those new to the field of outsider art, its most impressive—
and disturbing—feature is this impulse to contain everything, to assimilate
everything in the work. And because the work is created outside the usual
commercial channels of approval and reception, it is truly as if art is being

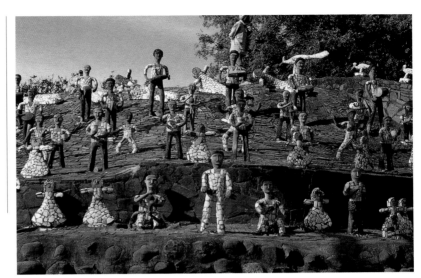

Nek Chand Saini
The Rock Garden,
begun ca. 1958, Concrete,
stone, glass, metal, and
other materials, 25 acres
Totalizing vision: Chand's
belief in God as a universal
force is embodied in
the sheer comprehensive-
ness of his rock garden
sculptures, which include
everything from monkeys
to waiters with trays.

proposed as an alternative universe. It is one thing if an artist proceeds in discrete works that have at least the appearance of individual identities, as Finster did, while he added to his Paradise Garden. This is the familiar model of artistic productivity. It is quite another to spin a continuous, private web of connections and elaborations, whose "parts" are often repetitive and less compelling than the overall project. Philip Travers (b. 1914), for example, has created an ongoing narrative in drawings about the adventures of King Tut, Mistaire Travair (the artist's alter ego), and Alice in Wonderland. The pastiche epic, inspired by science-fiction novels and unified by Travers's cartoon style, includes everything from amateur Egyptology to Humpty Dumpty's horoscope.

The clearest expression of this impulse is the environmental or architectural project, a consuming, continuous endeavor that yields an ever-expanding built structure. While these may begin as dwellings, they soon leave their practical functions behind. They become theatrical stages, allegories, autobiographical narratives, devotional acts, and monumental self-projections, sometimes all at once. There have been many thousands of these assemblages around the world, often sparking controversy and, after the artist's death, attempts to

Philip Travers
Time Tunnel, 1993–2002
Colored pencil and
marker on paper, 24 x 18"
Travers had some formal
training as an artist but
did not begin in earnest
until late in life and in a
totally different vein, as he
became a sampler of images
and texts from popular
culture à la Warhol.

save them. The projects range from the more conventional House of One
Thousand Paintings, which Sanford Darling (1894–1973) decorated inside
and out with his landscape paintings, to the futuristic four-acre Pasaquan,
constructed in Georgia by Eddie Owens Martin (1908–1986) in his visionary
identity as St. EOM. Not defined merely by physical expansiveness, the total-
izing impulse is equally manifested in the desire for a single object to contain
all experience. It is not clear when G. P. Ailers (active mid
to late nineteenth century) began working on his Adirondack-style desk, but
he worked on it until his death, elaborating its bentwood decoration into an
organic fantasy. The desk functioned, among other things, as a calendar, an
ark for memorabilia, and a cabinet of carved natural-history curiosities,
including grasshoppers, beetles, and snakes.

The totalizing ambition of these and many other projects reverses the usual priority of world and artist. It is not simply that the artist molds an alternative world out of his or her imagination. Artists always do that. What marks the outsider is the conviction that there is only one world, and that world includes, explains, and ultimately consumes the so-called objective world, turns it inside out. Jorge Luis Borges provided a striking image of this in his story "Tlon, Uqbar, and Orbis Tertius." It describes a vast fictional world, complete in every detail, created and elaborated by a legion of imaginative people by secret agreement, over the course of centuries. References to it are salted away in libraries and archives. Once it is discovered, it exerts an irresistible fascination and finally takes dominion over the ideas, values, philosophies, and actions of the normal world.

G. P. Ailers
Untitled (Desk and Chair),
1878, Wood with polychrome,
desk: 78 x 38 x 45",
chair: 35½ x 15¼ x 12"
When craft becomes
obsession: Ailers worked
on the desk and chair
for decades and was still
adding to it when he died.

Masters and Mysteries

4

In a field where each artist appears to invent a visual language and often does not seek to communicate with anyone but himself, herself, or God, can we really say which artists deserve broad attention? Do we have to wait for decades, even centuries, for the judgment of history, if indeed history cares to judge at all? Perhaps not. We can use our experience of art to identify works of compelling interest and value. This does not mean judgments must be hard and fast. All we need to do is glance backward across decades at the work championed by the Surrealists, Alfred Barr, or Sidney Janis to see how much cultural tastes have changed in just a few decades—and how much more scrupulous we need to be in examining the assumptions that underlie our taste. Henri Rousseau no longer seems exotic, alas, almost a cliché of "naive" art. Our judgments are bound to be disputed, and they should be. Even the accepted masters deserve to be con-tinuously reassessed. If nothing else, outsider and self-taught art should educate us in critical skepticism and independence.

It should also educate us in passion, for understanding usually comes only after we have already fallen under a spell. Only passion or its opposite, intense aversion, can engage our attention long and often enough so that we begin to ask and answer for ourselves the question "Why?"

In the following chapter, specific examples of work from each of twenty artists are analyzed for their formal, material, and symbolic qualities. I hope the basis of the choices will be clear from the brief presentations,

and that these analyses can serve as models for the kinds of attention that self-taught works deserve. I also hope the range of available interpretive approaches will awaken audiences to the importance of considering works from different perspectives. Readers may not agree with the choice of works or the interpretations, but at the very least they will gain a sense of the levels of response that can be engaged in appreciating these creations. The list should not be taken as an inventory of the "twenty best" outsider and self-taught works. Rather, these examples give a sense of the range of possibilities in outsider and the most idiosyncratic self-taught art. They also introduce several artists and works that are not well known. The critical analysis also includes some information about the lives of the artists, for biographical facts and artists' commentary can be important in understanding a work's origins, intentions, and methods.

GAYLEEN AIKEN (b. 1935? self-taught)

Me and Cousin Gawleen Walk and Dance Around the Green Light Clock and House at Night, for Fresh Air and
Exersize Like We Used To. A Loud-speaker was Hung Outside to Amplify Music Louder (Long Ago), 1996.
Crayon and ink on paper, 14 x 17"

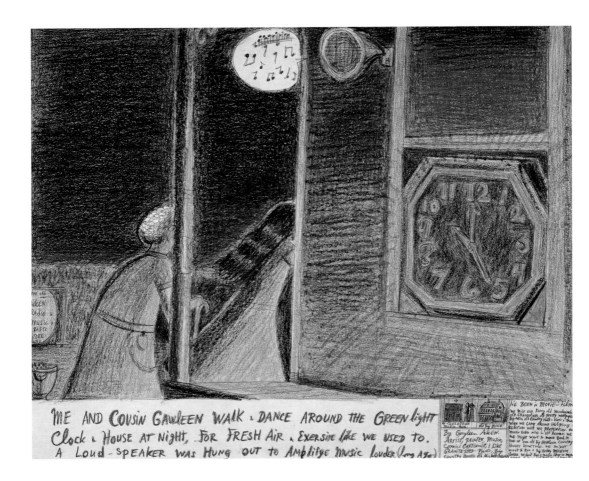

Looking at Gayleen Aiken's work is like opening Grandma's beaded purse and finding a Voudou doll inside. The Vermont native paints and draws memory pictures centering on her rural childhood, but the roots of her art lie deeper in her imagination. This picture, done in crayon and pen, shows the white-haired Gayleen and the young Gawleen Raimbilli, one of a family of imaginary cousins, all with the same last name, disappearing around the corner of a porch. The scene is lit by the glow of a huge octagonal wall clock, sitting in the window of Gayleen's childhood house. The entire picture is rendered in three colors—green, blue, and black—except for the red line of the clock's second hand.

Everything about the drawing is inordinate, from its segmented composition, which has the figures fleeing the dominating clock and loudspeaker and literally disappearing in front of us, to the use of green to bathe the image in artificial light. Judging from the caption, the image pretends to be a memory. But the event it depicts is an imagined ritual, a secretive dance before a source of light whose association with order and sequence is subverted by its Dionysian summons. The characters are doubles of each other. In many of Aiken's works, Gawleen acts out the disorderly pranks Gayleen never would, but in this image, the two are united in their night escapade. The ritual is shameful and joyous, the energy it taps is life-affirming and transgressive. Any sense of community, the anchor of folk art, is obscured by darkness and lost in a moment of abandon.

Aiken tries to recover an equilibrium in the title, with the hopeful reference to "fresh air and exersize." Her textual gloss seems to be a defense against the wish enacted in the image. This ambivalence runs through all her pictures, even the most innocuous, and it is so intense—involving a primal reaction to childhood encounters with the world—that she must tell stories about it again and again, in order to assimilate and contain it. She does not chronicle events, although her titles insist that she does. Instead, she attempts through art to reconcile fundamental conditions of experience that seem irreconcilable and to make that attempt public. If I understand Claude Levi-Strauss, this is the function of myth. Gayleen Aiken makes myths to repossess the world and her sense of selfhood within it.

MORTON BARTLETT (1909–1992; self-taught)

Untitled (Girl Reading), ca. 1950–60. Black-and-white photograph of carved and painted plaster doll, 3 x 4"

Between 1936 and 1960, graphic designer Morton Bartlett constructed astonishingly lifelike, not quite life-size mannequins of young girls in a variety of poses, as well as a series of carved and painted plaster faces. Taken together, this gallery represents an uncannily sensitive inventory of attitudes and expressions. It is clear that Bartlett had Degas's bronzes of young ballerinas in mind for some of the works, and he would not be the first to have fashioned such intense images of desire, or invested them with a kind of life. The dream and peril of Pygmalion haunt Bartlett's Barbies, and it is impossible now to view the works separate from prurience regardless of the artist's insistence that they were a "hobby." The power of the works lies in their parallel refusal to transgress, as Henry Darger does, or to cloak desire in whimsy, as many self-taught artists do.

At the deepest level, Barlett's work is not about violation but contemplation. We surmise this because he took carefully composed photographs of his creations. Again, Bartlett was not the first to couple dolls, desire, and photography. Apart from Cindy Sherman's work of the 1990s, the best-known example is that of the German Hans Bellmer, who created several articulated "figures" in the 1930s and photographed them incessantly. Bellmer enacted scenes with his dolls, rearranging their parts in a full-scale assault on the female body and, overtly, on the Nazi ideology of physical perfection. Photography in this case was pornographic witness of various acts of desecration.

Undeniably erotic, Bartlett's photos intend and achieve something Bellmer avoided—poignancy. They also reveal the power of the camera, by its fidelity to the subject, to bestow life. In three dimensions, the dolls are, finally, just dolls, near automata. But in front of the camera, they first become posed and captured individuals and then memorial, erotic remembrances. They take their place almost seamlessly among the vast archive of the once-but-no-longer-alive captured in photographs, and in death they gain a convincing vitality they do not have as objects. This double intuition of the nature of dolls and photography is Bartlett's complex achievement.

EMERY BLAGDON (1907-1986; outsider)

Untitled (Healing Machines), ca. 1955–84. Wire, wood, foil, glass, house paint, and other materials, various dimensions

Strictly speaking, Emery Blagdon's work does not belong in a discussion of art, for his creations were intended as instruments to heal the body. And yet they do belong, because Blagdon placed art at the very source of universal energy. A native of rural Nebraska, he began to create his "healing machines" in 1955, and forty-eight years later he had filled an 800-square-foot shed with his wire, wood, and metal creations. He strung them with lights and also decorated them with paintings on wood in strongly geometrical and abstract patterns that resemble Color Field paintings from the 1950s.

Blagdon believed that his assemblages generated electromagnetic energy that could help cure arthritis and other conditions in people who stood near them. They were reputed to be effective, and it is not out of the question that the sheer concentration of metal would produce alterations in an electromagnetic field. What prompted Blagdon to begin his constructions is not known, nor did he elucidate the functions of the different types of machines. Several patterns of organization have been identified, including multilayered squares and circular wall devices that look like turbine fans and hanging cagelike mobiles. Blagdon appears to have imagined a kind of energy map, that is, a set of pathways for energy to flow from its sources. Located face down on the floor, whose boards were also decorated, the abstract paintings probably played a crucial role in gathering and amplifying the energy, perhaps giving it a particular "form."

So Blagdon's creations are not machines in the conventional sense. Except for their electric lights, none of their components possess or demonstrate clear physical properties of operation. Their powers of healing and their organization appear to be above all visual, that is, they depend on the appearance and arrangement of the assembled forms themselves and not on some underlying physical, or even psychic, principle. They are not built from the inside out, so to speak, but from the outside in. Blagdon himself admitted he had no idea how the machines worked. That the paintings, the primary source of color in the constructions, appear to be the energy conduits and the reflective foil and lights create the overall effect, indicate that we are in the presence of an aesthetic object, first and foremost. In other words, Blagdon has made not a machine but a metaphor for a machine. He called his constructions "my beauties," and thus conferred on them a power different from that known to physics. An obvious comparison is with the kinetic sculpture of the Surrealist Jean Tinguely (1925–1991). But while Tinguely transformed machines into spectacles, Blagdon created a spectacle that would transform human beings. Of the two, Blagdon, the nonartist, believed more strongly in the power of art.

PEARL BLAUVELT (1893–1987; self-taught)

All Sizes—Both Silk—and Cotton, ca. 1940. Graphite and colored pencil on paper, 8 x 10"

When is restriction a form of liberation? For Pearl Blauvelt, the very narrowness of her world, limited to the shop where she worked, the house where she lived in western Pennsylvania, and a handful of scenes from her immediate purview, apparently gave her all she needed to inspire a detailed, painstaking, and faithful inventory of the contents of daily life. She might be thought of as a female James Castle (1900-1977), the self-taught artist from rural Idaho born deaf and mute, who meticulously rendered all the houses he lived in.

The mystery of drawings like these is that they seem to arise out of two simultaneous and diametrically opposed impulses: a tentativeness in the face of life, which encourages one to make the bond with reality a bit more secure and intimate, and the small pleasure of simply being here and showing it—drawing as a kind of existential tinkering. Yet Blauvelt has something else, a draftsman's determination to get the picture right, complete, and precise. In drawing after drawing, she works out spatial relationships with a restricted compositional geometry as she tries to force a three-dimensional world into two dimensions. Like Castle, she seems to have taken her cue from her materials, often using lined paper, which helped her order her compositions. She lacks Castle's spontaneity, but we can almost feel her satisfaction at putting things in their exact relation.

Blauvelt's rendering of stockings for sale, copied from a Sears and Roebuck or Montgomery Ward catalogue, possesses the antique charm of folk art, of bygone times, but her eye for pattern and repetition, for purely abstract qualities that she carefully reinforces, gives her work an appeal beyond nostalgia—and perhaps a slight chill. She celebrates unpopulated spaces and serendipitous order. Above all, she offers glimpses of a perfection that seems to lie outside of time and circumstance, although it captures them exactly. Blauvelt lets us know right where we are: in that place, among those things, at that time, and for eternity.

NEK CHAND SAINI (b. 1924; self-taught)

The Rock Garden, begun ca. 1958. Glass, stone, concrete, slag, and diverse found materials, figures approximately 60" tall

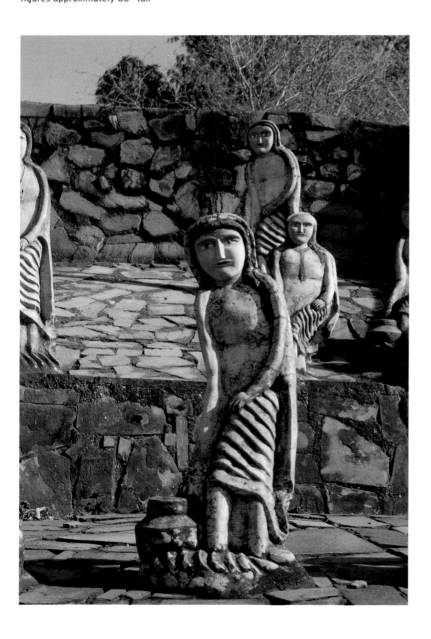

In northern India, monuments to the past are everywhere, from great ancient forts to Jain, Sikh, Buddhist, Hindu, and Islamic temples, to the observatory at Jaipur. Their façade decorations are overwhelming in their intricacy and organized profusion, all-encompassing in their imagery, crowded, elaborate, vivid, and alive. This vast inclusiveness must surely have inspired the Inspector of Roads Nek Chand to begin his own cosmological enterprise, The Rock Garden of Chandigarh.

Like outsider art, architecture is rife with comprehensive utopian projects, with decorated extravaganzas that seek to promote a heaven on earth. What sets Chand's lifelong project apart is its deep connections to the rich architectural heritage that surrounds it and the seriousness of purpose behind it. In his early sculptures, Chand often copied Hindu figures. Yet the larger project rises above explicit sectarian religiosity. The artist has offered his project as a spiritual celebration of beauty in its many forms and of humankind itself. Beginning as a handful of sculptures made from refuse, the garden has evolved over forty years into a 25-acre "kingdom," with gods and goddesses, temple domes, bridges, and waterfalls.

Although originally intended for Chand's solitary pleasure, his enterprise—far from being "outsider"— is wholly expressive of his wider sense of community, with both India and the world. The only difference between the Rock Garden and the great monuments of India's past is that it is unsupported by doctrine and is the vision of one man.

Yet Chand's Rock Garden is also in tune with the present. In the 1950s, Chand worked on the construction of the new city of Chandigarh, designed by Le Corbusier, and carefully studied Le Corbusier's techniques. While incorporating these into his own constructions, he has also elevated recycling to a cosmic principle, a notion consistent with Hindu beliefs in a cyclical universe. Materials have engaged his intellect to such a degree that there is almost no discarded object that he cannot use, from rags to oil drums to fluorescent tubes; as a result, the Garden has become one of the largest recycling projects in India. Chand has the ability to look beyond the ordinary uses and damaged destinies of discarded objects to see in them the seeds of their rebirth. This may be his Rock Garden's greatest gift—the demonstration that paradise can rise from society's waste.

HENRY DARGER (1892-1973; outsider)

22 At Jenny Richie at Hard fury/2000 Feet Below, side A, ca. 1950-60. Watercolor and graphite on paper, 17 ¾ x 47 ¼"

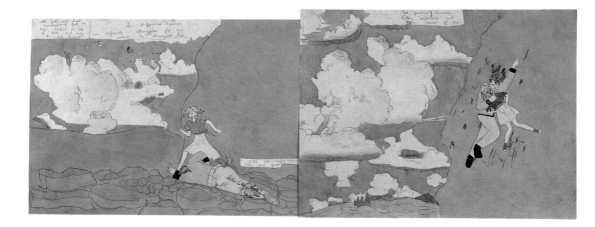

Some have argued that labeling Henry Darger an outsider is presumptuous, since no one seems ever to have asked the reclusive Chicagoan what he was up to or what it meant. Yet it is hard to imagine that he intended his vast visual and textual epic of war and carnage inflicted on prepubescent girls to be seen by anyone else. Or rather, he did conceive an audience, since his prose is sententious and his imagery grand, but he himself stood in for that audience. We can imagine him confronting the spectacle of what he had created and indulging in a conflicted autoerotic pleasure.

So Darger represents a closed circle, and we enter it at our peril. This drawing (actually one side of a two-sided work) provides an especially distilled example of the elements of his inner struggle. The picture is literally divided in two and represents an impulse and the reaction against it. The impulse is to strangle an object of desire, one of the so-called Vivian Girls, and when Darger gives in, as he does thousands of times in his visual epic, he stops trac-ing and begins to actually draw. In these moments of inept expression we can feel the attack taking place. And then the reaction, the wrath directed at the adult predator and all he represents. He falls "hundreds of feet" to his death; the girl lands on him and then steps delicately over his lifeless body.

Such a conflict can never be resolved because it is ingrained in the very awareness of desire, and Darger's work would be monotonously psychological if not for one thing—the backdrops against which the war is played out. Darger marshals a graphic sense as bold as any ever seen to create a natural world that heralds and amplifies the titanic events it frames. The roiling clouds and blood-red mountain tell us that we have entered an allegorical universe, where the battle in the mind, represented in image, mirrors a battle on the cosmic scale. Darger is a sinner in the hands of an angry and unseen god, and he scrutinizes the heavens with more attention than any weatherman for the signs of judgment and the portents of disaster.

CHARLES A. A. DELLSCHAU (1830–1923; outsider)

Untitled, 1920. Mixed media on paper, 17 x 17"

A butcher by trade, Charles Dellschau created a microcosm in which history and fantasy could coexist. He made his art in private and sealed it in notebooks, apparently never intending others to see it. It has all the earmarks of a delusional system: compulsive detail, the impulse to subordinate all aspects of experience to a single scheme or preoccupation, and the steady elaboration of that scheme over many years. Yet Dellschau's work is directly connected with its time and colorfully celebrates it, and that connection gives the work its appeal. Indebted to a range of visual sources, including circus and sideshow advertising, it engages what was for the artist the most important event in history, the advent of manned flight. Indeed, the Wright brothers' achievement may have been what spurred Dellschau to draw in the first place.

He seems to have imagined a mid-nineteenth-century flight club and its flying machines, called aeros, more spectacular than any airplane. They are a cross between dirigibles and winged balloons, brilliantly colored and elaborately patterned. In contrast to, say, Leonardo da Vinci's drawings of helicopters, these works display less interest in the actual mechanics of flight than in the sheer fact of it. Visual pattern is more important than underlying principles, and the wheels and pulleys in some drawings do not so much explain how the machines work as reaffirm that they are the inventions of men, indeed of one man. The machines and their decorative borders are part of the same visual system, organized, numbered, and populated with characters created by Dellschau himself. He also incorporates contemporary newspaper clippings about flight, especially its disasters and its miraculous possibilities for good.

These features, and Dellschau's tendency toward elaborate captioning, suggest that the artist saw his project in both fictional and prophetic lights. He labeled one drawing "Dream and Real," as if he had projected himself back in time to a period before airplanes in order to imagine a future that was, in reality, already taking shape around him.

JOSEF HEINRICH GREBING (1879–1940; outsider)

Untitled (World Map), ca. 1920s. Mixed media on artists' board, 16¾ x 11¼"

When the Nazis instituted their policy of eliminating the mentally ill, they deprived the world of a voracious and complex creative intellect. Josef Heinrich Grebing, a learned and devout businessman from Magdeburg, Germany, declined into madness, and was institutionalized before the Nazi takeover. In his art he seems to have grasped desperately at the remnants of a life that had slipped away—a life of calendars, times, dates, organizations, receipts. In his notebooks, Grebing devised elaborate business certificates, laden with official seals and medals that resemble the parodies of cartoonist Saul Steinberg. He calculated a hundred-year calendar down to the last detail, and developed a precise, beautifully abstract color chart as well as an inventory of small graphic symbols, much like computer dingbats. More ominously, he also drew up a "Murderer's Chronological Calendar–Headsman's Calendar." The attempts to impose order, even negative order, poured out of him.

One of his most grandiose and delicate images is this map of the world. It is topped by a detailed smaller map of what he labeled the Grebing domain in Germany and bordered by his versions of what appear to be hemispheric and planetary maps. The world map itself is crisscrossed by various diagonal lines that tie the continents together in some geometric scheme relating to longitude lines. Following antique conventions of the *mappa mundi*, Grebing's vision elaborates a cosmology in dimension after dimension of organizing frames—local geography, beginning with his own name, the landmasses and their connecting schema, the globe, the heavens. At the bottom of the map is a staff of music and the words "Dies Irae" (Wrath of God), indicating a religious chorus. In a band just above the notes and below the map are what appear to be flames.

As in so many of Grebing's pages, stunning as they are, a force seems either to sabotage the order directly or to suggest its ultimate destruction, and that threat generates an ever-more-frantic and elaborate attempt to bring every last element of time and circumstance into line.

WILLIAM HAWKINS (1895–1990; self-taught)

Untitled (Dustbowl Collage), 1989. House paint and newsprint on wood, 35½ x 48"

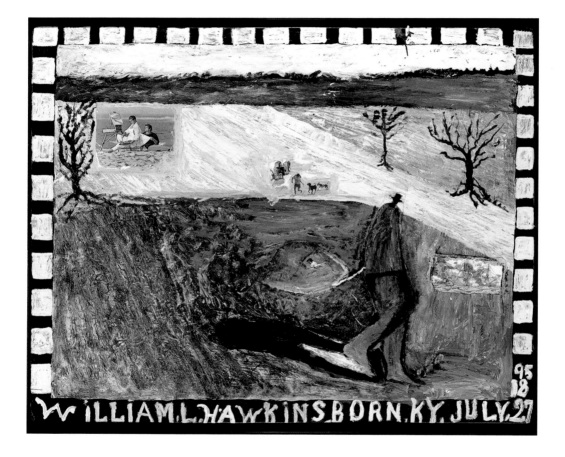

William Hawkins defines many aspects of the self-taught artist and overturns many of the stereotypes. Never doubting the importance of art or his identity as an artist, the Columbus, Ohio, painter lived to create beautiful things. "There's a million artists out there," he once said, "and I try to be the greatest of them all."[35]

This painting, from the annus mirabilis of 1989, in which the artist did much of his best work, is the last that Hawkins completed before his death. The somber image of a dark figure in a stovepipe hat striding through what appears to be a winter landscape is peppered with small scraps of photographs taken from magazines—a child playing with dogs in a field, a grownup walking with children. At the center, near the striding figure, in a swirling vortex of paint, is a tiny fragment of a WPA-era photograph of a toddler. The dark figure, which may be death or the artist, strides toward another collage element, an engraving of a battle between sailing ships. Finally in the top left corner, Hawkins gives us a vision of pleasure: He has affixed part of a liquor ad showing a woman painting at the beach while her boyfriend tugs at her clothes.

Here is an example of the category "late works"—reflective images that comment on an artist's vocation as well as on the cycle of an individual life. Western art is rich in such images, from the Sistine Chapel to Picasso's prints. Hawkins uses photographs here to add a personal psychological dimension, the arc of his own human progress, to what is basically an archetypal image of darkness and light.

Hawkins does not always employ photographs in such a complex way. They are first and foremost shortcuts for elements that are difficult to render. But his instincts about when to paint and when to paste are uncanny. He gives many of his animal figures collaged eyes, transforming the two-dimensional renderings into living creatures of the imagination. Likewise, by inserting a tiny photo of Soviet premier Nikita Khrushchev, waving, into the middle of his Constructivist-inspired, red, white, and black painting of Red Square, Hawkins evokes the absurd monumentality of Soviet military and architectural displays. In all these extraordinary works, painting sustains the collage imagery that inspires and completes it. Although lacking the cultural knowingness of a postmodern aesthetic, Hawkins's borrowing has a specificity that contemporary art often lacks. It is exactly the opposite of that found in Pop artists such as Rauschenberg, who set painting and photography against each other. In Hawkins's work, painting and photography confirm each other.

JONATHAN LERMAN (b. 1987; outsider)

Untitled (Portrait of a Woman), ca. 2000. Charcoal on paper, 24 x 19"

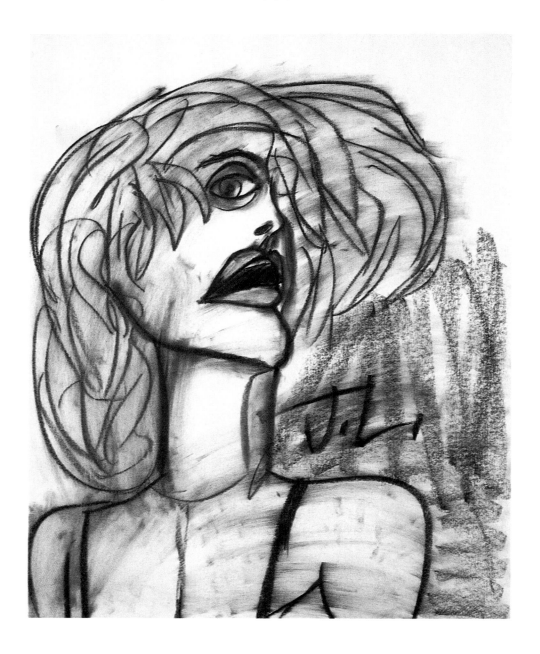

At the age of eleven, Jonathan Lerman could scarcely communicate verbally, but he learned to draw with astonishing rapidity. He didn't learn as other children do, graduating from stick figures to drawing in the round. Instead he started with cartoonish bits of faces—eyes, nose, chin, teeth, mouths. Then, after the briefest apprenticeship, he began to assemble these elements into evocative, unforgettable portraits.

Done in single rapid takes, his drawings have the freedom that artists of an earlier century achieved only by discarding their own academic training. Auguste Rodin (1840-1917), for example, sought to master a kind of automatic drawing, never lifting his pencil from the sheet as it followed the contours of the subject. Lerman's ability to intuit the visual essence of a subject in bold lines and deliberate smudging requires no such literal caressing. He doesn't need the subjects present to call them up. Lerman is unusual for an artist with autism in that he focuses so intently on people's faces and seems to possess an uncanny grasp of his subjects' emotional states—the wild disarray of this woman's hair, the anguish of a cry—despite the fact that he is often reacting not to an actual human being but to a photograph or an image on a TV screen. The "subject" here may be a photograph of the actress Hedy Lamarr.

In Lerman's work, the drawing process takes on a life of its own, mediated by the artist's fixations. Lerman has an instinctive, not logical or learned, sense of depth and proportion, which he alters as he moves. Indeed, the closer we look, the more the drawing seems ready to fly apart into its powerful elements: hair, eye, and mouth. What gives the portrait its unity, then? The strong outline strokes of shoulders, neck, chin, and profile shoot up toward the dark interruptions of mouth and eye. Such certainty is Lerman's trademark. When our gaze is arrested by that eye, we have to ask, What can he know about such a person? Nothing but what he sees. And that is all we can know.

MARIE LIEB (dates unknown; outsider)

Untitled (floor decoration), ca. 1894. Strips of torn cloth, no dimensions

Like so much contemporary installation art, Mary Lieb's work survives only as a photographic record. She was institutionalized periodically in Heidelberg for mania, and that is all we know about her. The evidence of her incarceration art was gathered by the physician Hans Prinzhorn for his collection of the art of the insane. Lieb practiced "women's work," using domestic materials that she was familiar with—white cloth torn in strips. She decorated the floors of various rooms with these, and her warders found the patterns remarkable enough to document with a camera.

The patterns are extraordinary, comprising rows of starbursts (or perhaps flowers), letters, crosses, geometric patterns, and sometimes intricate curved figures. Their purpose and organization are unclear, but like much outsider art, the work appears to be a combination of decoration and communication, an attempt to reorder the space "from the ground up," visually transform it, and invest it with new significance. The floor becomes an important symbolic space, not just because it acts as a canvas but also because, decorated, it reverses all the ordinary values of things. The ignored space of walking becomes the new space of beauty and, perhaps, revelation. Although it does not make sense to speak of such a work's affiliations, its suggestiveness is rich, from Voudou ground drawings, which serve to define sacred space for a gathering, to the ritual pigment drawings of northern India, which are meant to ensure good fortune and are wiped out each day by traffic and weather, to the ephemeral floor patterns created by contemporary artist Polly Apfelbaum (b. 1955). In the Indian traditions, the drawings are often done by women, and the act of making the patterns is considered propitious in and of itself. Lieb's artwork binds together disparate realms and anchors spiritual, even magical, practice in a specific place.

MARTIN RAMIREZ (1895-1963; outsider)

Untitled, ca. 1950s. Crayon and graphite on paper, 47½ x 37¼"

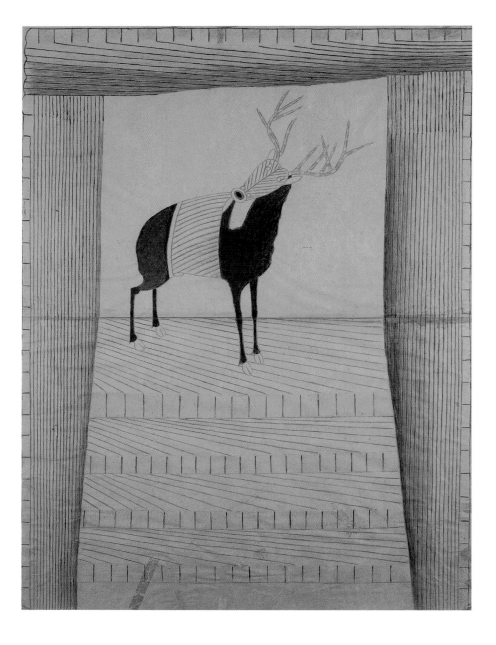

When the conquistadores shattered the indigenous societies of Mexico, they also shattered the indigenous languages. These languages were visual and spatial, using pictorial symbols and spatial relations to narrate ceremonial events. The scribes who came after could not reconstruct the visual maps, even if they knew some or many of the characters.

Although Martin Ramirez was probably not an Indian but a Spanish-caste native of Jalisco, and although he lived four hundred years after the conquest, he, too, in a time of extreme mental crisis and isolation, using the visual forms he knew, set about creating a map of his past—to orient himself and perhaps take inventory of what he had lost. After being homeless in Los Angeles and apparently unable to communicate, he was eventually committed to a California mental institution, where drawings began to flow out of him. Done against the orders of his warders, these works were gathered first as lecture material on psychopathology and art. Later they became folk curiosities, "obsessional art," and still later, through the attention of Nobel laureate Octavio Paz, the expression of the essence of Indian Mexico. But it was only through the work of the dealer Randall Morris, assisted by the artist Jose Bedía, that Ramirez is gradually being seen as an artist who marshaled all his resources to shore up a shattered world.

Simple images, such as the deer pictured here, show the symbolic and personal richness of those resources. Ramirez never drew casually. He worked in bursts and often made multiples of single images, perhaps because he knew some would certainly be lost. Deer were important to the life of Ramirez's hometown, both as food and as animal presences. So he consistently places this animal, as he does cowboys (actually a type of Mexican gaucho of the north), in a proscenium niche, like the statue of a saint. The deer always assumes the same posture, with the head at the same angle, and stares back with empty circular eyes. The repetitive detailing around the proscenium has been seen as obsessional, but more likely it is repeated, as it might be in church decoration, to emphasize the importance of the scene.

Ramirez was almost certainly Catholic, and yet Christian visual forms—church architecture and detailing—seem more important to him than religious iconography. The artist's larger project, which included views of towns, landscapes, railroads, highways, and tunnels, was the reconstruction of his personal history, the worship not of God but of his past. Ramirez selected those scenes and elements of greatest resonance and linked them as in a map. And it may be that the deer had a special place—the central place—because it stood for the artist himself.

HEINRICH REISENBAUER (b. 1938; outsider)

Untitled (Yellow Umbrellas), 2000. Graphite and colored pencil on paper, 8¼ x 11⅝"

Heinrich Reisenbauer is one of the residents of the Haus der Künstler at the Gugging Psychiatric Clinic near Vienna, an art colony founded by the late Dr. Leo Navratil. His work is less well known than that of many of his fellow Gugging artists, but since 1986 he has produced a body of work that is instantly recognizable and among the most compelling, both in its simplicity and its accessibility. Reisenbauer renders objects—chairs, umbrellas, cups, cherries—in a precise graphic style, in a single color. He repeats the image over and over in rows, until he feels the sheet is complete. He never varies from this format, and yet each of his drawings is distinct and memorable.

Contemporary art helps us appreciate this unusual work. Andy Warhol introduced the notion of the multiple, the idea of a repeated (and reproducible) image that undermines the putative originality and uniqueness of a work of art. Which *Marilyn* came first? Which yellow umbrella? Yet for all his repetitions, Reisenbauer follows a different path. He clings to his objects with impossible affection. In this drawing, each of his umbrellas is slightly different, the handles longer or shorter, the bodies wider or narrower. They offer variations on a theme, all of them versions, perhaps, of some ideal type that can never be seen, only embodied in its diverse forms. Reisenbauer seems to take the most interest in rendering nuances and minute alterations. It is an interest inherent in much Minimalist art, such as the white paintings of Robert Ryman (b. 1930). The dominant impression is not so much one of obsession as of joy, the joy of discovering in one thing the comforting consistency of the type and the infinite multiplicity of the whole world.

JUDITH SCOTT (b. 1943; outsider)

Untitled, 1994. Mixed media, 20 x 20 x 55"

Judith Scott's work presents the most profound challenge to aesthetic interpretation. Born with Down's syndrome and institutionalized for twenty years, Scott creates pieces by wrapping twine and yarn around a core object or objects, which include plates, shovels, sticks, and even toasters. As the construction grows, she sometimes incorporates other objects, which are gradually wrapped in. The textures of the pieces range from tightly wrapped and carefully shaped to ragged and porous, with objects such as cardboard tubes protruding from inside.

Although writer John MacGregor has argued that Scott's objects are representations, he acknowledges that the process appears to be far more important to her than the formal outcome. He also notes Scott's earliest tendency to cradle her creations like dolls.[36] The real challenge to interpretation is not whether these are effigies or even substitutes for babies, but whether they are for Scott living beings. The process of swaddling or hiding an object suggests the need to protect something living, and the incorporation of other objects as she works implies an organic process of growth and ingestion. Likewise, the spectacular and variegated colors of the yarn seem to signify something changeable and alive.

Or perhaps just the opposite. These objects also resemble mummy bundles, protecting a secret from the other end of life, the residue of spirit. In any case, they clearly suggest responses to primal processes. The roughest pieces, especially, whose core objects—often sticks—are poorly wrapped, possess a disturbing sense of near-life/near-death that lies beyond the capacity of art qua art to evoke. One of the few comparisons is with the work of Eva Hesse (1936-1970), so strongly oriented to the physical body without ever imaging it. On the one hand, Scott's works display the process of a mind assembling something from nothing yet leaving the project somehow incomplete, suspended. They are almost but not quite things. On the other hand, the object itself seems to be struggling to come to life, or to avoid being smothered. It is as if we were watching a butterfly emerging from a cocoon or attempting to escape a spider's web. These works evoke the uncertainty and fear we feel at the borders of our fundamental categories of experience, of animate/inanimate, made/found, self/not self, and, inevitably, birth/death.

JON SERL (1894–1993; self-taught)

Gone, Just Gone, ca. late 1970s. Oil on board, 24¾ x 19"

Someday, perhaps, it will be possible to separate the facts of John Serl from the legends that grew up around him. Serl himself fostered these among the hangers-on, bikers, homeless people, and the curious who came to visit his ramshackle house in the mountains of southern California. And many of the legends are true: he was a vaudeville actor, who was beaten by his father to make sure he stayed thin enough to take women's roles, a film extra, and a shrewd manipulator who entertained a cult of followers and took in stray human beings the way other people take in cats and dogs.

Above all, however, he was a painter, who worked steadily, no matter how outwardly chaotic his circumstances, for more than forty years. His protean, theatrical sense of identity, often expressed in spectacles of fluid form that suggest obscure and sometimes menacing ritual, and his complex sense of color mark him as someone for whom the act of painting was as important as the meaning of the image. Serl's approach was to use ordinary materials, from boards to window shades, make his own gesso to cover the surface, and then improvise, summoning the scenes from memory and imagination suggested by the pattern and texture of the surface. This is an art of maximum risk,

in which the artist sets no program or boundaries to hide behind but depends entirely on the symbolic repertoire of his inner experience and his ability to render it. In this radical self-sufficiency, Serl the outsider resembles above all the great American barbarian Jackson Pollock.

Both artists sought beneath the strata of their painful memories and ambivalent cultural experience a mythic imagery that would transmogrify particulars into vivid universal presences, into forms that might make being directly manifest. This is psychological autobiography, not memory painting. Yet while Pollock regressed through Native-American forms to inchoate sources of psychic energy, Serl held to ideas about these forms, such as the triangular tepee, to organize his compositions and to render the energy he saw embodied in things around him. Pictured here, his pet chihuahua is all gaping mouth, comic if it weren't so sudden and huge. Animals held enormous significance for Serl, and he often imagined and pictured himself in their guise. Placing himself at the border where human beings are only one power among many, he called down the lightning in each work and often recited a kind of mantra when painting: "Don't be afraid."

RICHARD SHARPE SHAVER (1907–1975; self-taught)

Antediluvian Rock Book Painting, n.d., Mixed media on cardboard, 17½ x 16¼"

The most difficult challenge posed by the paintings of Richard Shaver is to keep our attention on the art, for Shaver's obsession was so commanding that it invites comparisons with the blinkered theories of characters created by Jonathan Swift, Jorge Luis Borges, Italo Calvino, and other satirists. Writer, artist, and sometime factory worker, Shaver believed he had been contacted by remnants of an ancient civilization, long since fled from Earth in spaceships. This antediluvian race left traces in rocks, which Shaver "discovered," as if he were looking at Rorschach blots, photographed, and later used as the basis of his paintings.

The shape and detail of Shaver's ideas follow a delusional pattern common among many people diagnosed as paranoid psychotic, but our interest is on the artistic process, not the particulars of delusion. Shaver developed a painstaking method for shaving thin slices of rock; after photographing them, he projected his "rock book" images onto canvas and built up the surface with glue and aluminum paint to emphasize the patterns—usually humanoid forms—supposedly formed by the pressure of the light. The rough textures and crude imagery resemble a host of 1960s neoprimitive figural approaches, from the *art brut* mannerisms of Jean Dubuffet to the aggressive painting of Argentinian *Nuevo Figuración*.

Shaver's deeper kinship lies, however, with the Conceptual and process-oriented artists of the 1960s, who reacted against overt expressiveness in art. A host of painters, including Chuck Close in the United States and Gerhard Richter in Germany, adopted seemingly arbitrary methods, including painting from photographs, as a way of taking the artist as much as possible out of the picture. Close's rigorous grid system functioned much the way Shaver's elaborate system of geological revelation did, generating a set of consequences from a restricted set of conditions. As Close once remarked about his method, it was "to sign on, ship out, and see where the process took me."[37] Shaver couldn't be so up-front. His own obviously self-satisfied descriptions of his method ignored at every turn the human, intentional interventions that in fact yielded images. He acted as if all the artistic and technical decisions he made to produce a painting were not his choices but simply "in" the materials themselves. Small wonder then that when his first writings about the Atlantean kingdoms were published not as history but as science fiction, the irony appears to have escaped him.

OSWALD TSCHIRTNER (b. 1920; outsider)

Ein alter mann wird gespeist [An Old Man Receives Food], 1992. Ink on paper, 8½ x 5¾"

Tribal art around the world shows us that "realistic" portrayal of the human figure has been the exception rather than the rule. But the distortions of tribal art are sanctioned by a community's sense of what is significant about the body. What, then, gives Oswald Tschirtner, a resident of the Gugging Clinic, permission to reduce the human figure to head and feet? Perhaps satire, if he demonstrated any political views. More likely, the image comes from a deeper sense of how things seem, or perhaps simply from being able to do only this and nothing more with the figure. In any case, Tschirtner has provided a resonant cartoon image of modern humanity, in which the comic and tragic aspects go hand in hand.

The "headfooters" in this drawing are old men receiving food, something Tschirtner would know about from his age and hospital status. What is an old man—just a small head, a nonbody, and feet that are more like useless tentacles? And food—simply a round ball of stuff? This is not a cheery picture, and yet its reduction to an absurd level gives the image an undeniable pathos. As with all of Tschirtner's drawings, we cannot help confronting fundamental conditions, and we take comfort from the fact that we are all in the same leaky boat.

Tschirtner's gift is the reductio ad absurdum that dispenses with particulars and brings a generic situation or object into focus. In this, he is the opposite of his Gugging colleague Heinrich Reisenbauer, who produces minute variations on a general theme. Not only people but also skyscrapers (two nearly abutting L-shapes), a snowfall (rows of tiny circles), even a rope (a series of horizontal lines) are stripped to their visual essence. There's comedy in seeing the world taken down a peg or two, as well as awe in the face of the prototypical and unchanging. From just such a symbolic experience, tribal art, too, derives its power.

AUGUST WALLA (1936–2001; outsider)

Untitled, ca. 1980s. Photographs of Walla gesturing in front of a demolished building, painting a tree with a "pagan" sign, and his decorated room at the Gugging Clinic.

In writing about his most talented patient, Dr. Leo Navratil of the Gugging Clinic came close to the core of the titanic force that was August Walla: "He has the power to erect an order of things."[39] Walla, who apparently suffered some form of neurological impairment as a result of childhood encephalitis, would be justly famous for his drawings and wall drawings alone. But Walla went far beyond drawing, reconstituting the German language in visual presentation, reinterpreting words from other languages, taking his signs into the world, and recording their placement with a camera. He even created recipes and wrote music. Walla's complicated symbolism is a mix of holy figures, political symbols, and personal images, and his total immersion in the sound, sense, and visual appearance of words is the most radical approach to language since the German poets of the nineteenth century.

Dr. Navratil has also written that Walla's thinking was magical in nature, with its coupling of animate and inanimate realms. Indeed, the artist seems to have dedicated himself to erasing the boundaries between inside and outside, between self and not self. He did this by taking his text and images directly into the world, placing them in various locations, and photographing himself with them. In these gestures he identified nature as a living force and sanctified all the corners of reality, including urban ruins, with pagan signs, as he terms them. Functioning as a kind of shaman, Walla summoned forces positive and negative to galvanize and unify a fragmented world. In this he resembles above all the artist Joseph Beuys (1921–1986), a mainstream figure who adopted a self-consciously shamanic role. As with Walla, Beuys's diverse art has never been fully assimilated into any movement.

The significance of Walla's photographs is that they record a performance, one that reveals the deeper motivations of the artist. Walla repeatedly positioned himself in front of his work, with his hands upraised near his face. This appears to be his version of a prayer or supplication, modified from church forms. Yet he also demonstrated different variants of the pose, appearing to cup his ears, to display himself as a sign (as did Jesus with his stigmata), and even to ward off or cast away some influence. His purpose in making photographs apparently was to confirm the acts in the objective world and, by extension, their efficacy. This ritual binding of self and world against the trauma of separation, conducted in every medium including the embodied one of theater, is unlike anything else in outsider art, or indeed in Western art. Walla takes his place as shaman not for tribe but for humankind.

MELVIN WAY (b. 1954; outsider)

Untitled (Chocolate Limen), 1990s. Black ink and tape on paper, 12 x 9"

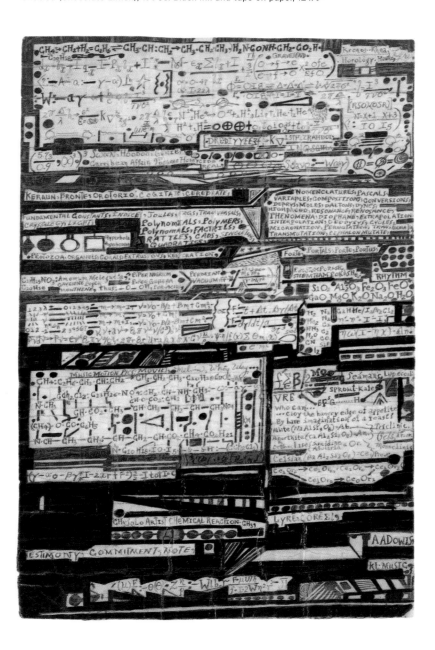

We live in a time of science and pseudoscience. Achievements so complex they cannot be understood by the uninitiated and seem like magic or hoax have spawned their opposite in a growing conviction that anything is possible and evidence unnecessary. Cold fusion, creation by design, the Matrix—can any logic disprove them if life can be cloned? In this atmosphere of bafflement and credulity, the work of Melvin Way takes on an emblematic significance. He gives us a broken image of the quest for perfect order and total understanding.

Way's drawing first came to light after he participated in an institutional art program in New York. Using pen and scraps of paper, he creates visual architectures of chemical formulas, mathematical equations, and words. Way briefly studied science and mathematics in high school, and it seems to have left him with an impression of an elaborate unveiling of the hidden order of things, of the world's secret symmetries captured in symbols. Looking at these drawings, however, we also have the sense of letters and numbers with a life of their own, spinning an autonomous web of figuration. In this scheme, the associative word strings and formulas have the same status, the same visual role to play, as language unhinged from normal signification (the equations do not "add up"). Both Paul Klee and Adolf Wölfli had a similar sense of language as a set of purely formal relations. What makes Way's outpourings art is their visual organization, their structuring schemes that connect the elements in a discrete, albeit ragged edifice. In this drawing, there are also hints of connecting structures, like molecular diagrams, that suggest the piece is at once spontaneous and, in scientific terms, self-organizing.

There is one other dimension that links Way and Wölfli: music. Like the notes that fill many of Wölfli's compositions, Way's words and phrases are meant to be sounded, in a jazzlike recycling of the many verbal influences he absorbs, from physics manuals to works on the occult. His art is structure and performance; its universe sound and symbol.

ADOLF WÖLFLI (1864–1930; outsider)

General View of the Island of Neveranger, 1911. Colored pencil on newsprint, 39¼ x 28"

"For the Heavenly Ones are displeased if someone does not pull himself together, sparing his soul."[38] So wrote the nineteenth-century German poet Friedrich Hölderlin when he was hemmed in by madness. These words could serve as the epitaph of the prodigious Adolf Wölfli, the incarcerated child molester, poet, musician, graphic artist, and occasionally violent Swiss-German schizophrenic. The two artists represent a pair of bookends, two who were broken apart from the world and who attempted, with mighty and damaged tools, to repair the split. For Wölfli and Hölderlin (and many other German Romantic artists inspired by the philosopher Immanuel Kant), human consciousness is burdened with a hyperawareness of its separation from the essence of things, its absolute isolation. It is an island buffeted by storms, with at best only intimations of a primordial connection to the world, glimpses of recovered innocence and divinity. The compensation is language, a self-transcending means to express unity and build bridges but also an abstracting medium that puts the world at an even greater distance.

Hölderlin set out to renovate the German language; Wölfli to break it open, to make it serve new uses. He turned it into syllables, to pure graphic forms, to numbers, to nonsense, to maps, pictures, musical notes. In other words, he made it the glue of a unifying project that would bind together all aspects of his personal history, his knowledge, and what he sensed and imagined about the universe. So that he would not be what he was: alone, a stranger to himself, and homeless in the world.

Neveranger, one of the imaginary geographic locales of his illustrated epic autobiocosmography, *From the Cradle to the Grave*, is a quintessential attempt to organize experience in a way that is not preordained but instead unfolds until it is complete. Elements such as faces, sun imagery, musical notes, and Christian symbols are linked by sinuous lines as a series of local orders. In spite of the work's title, it is not a true map or floor plan but rather a cathartic episode in an emotional, symbolic narrative—an illustration of something that, even if once seized, must be grasped-for over and over again. Each piece seeks to put the damaged self in a cosmic context and thus transform it. Much has been written about Wölfli's output, but establishing his place in the universe was a full-time job, one from which it was impossible to rest. Tens of thousands of pages might not be sufficient. No wonder Wölfli came to assume the artistic identity of an imaginary saint, Saint Adolf.

"A Servant of God without a Head is More Miserable than the Most Miserable of Wretches." So wrote Wölfli, like Hölderlin cast out from the Land of God and only his pencil to get him back in.

Outside In: The End of Outsider Art

In her fascinating history of material exchange during the Renaissance, Lisa Jardine describes a spectacular gem-encrusted, multitiered helmet made for the Ottoman emperor Suleiman the Magnificent in 1532 by Venetian goldsmiths. Incorporating various motifs and styles, from the papal tiara and antique Byzantine medals to the ceremonial turbans of his own court, it was delivered to Suleiman in anticipation of a great battle he intended to launch against Christian forces at Vienna.[40]

Artists, especially those on commission, are inveterate borrowers, and they do not respect categories of outsiderness, or even categories of friend or foe. They scavenge visual ideas, suggestions, knowledge, tricks, wherever they are to be found. Like the Venetian goldsmiths, they can make a helmet for a sultan that can also impress a pope or a parliament. As we have seen, Western insider artists, whatever their motives, have continuously borrowed from groups, cultures, or individuals considered "other," inferior, primitive, or anonymous, even when those cultures threatened their world. And most other cultures in the history of human civilization have done the same. In modern times, artists from Manet to Dubuffet have appropriated aspects of primitive or outsider art (for Manet, it was Japanese art) as a means of aesthetic experimentation and social iconoclasm. In Dubuffet's case, as we have seen, the primitive and the outsider became weapons in an attack on culture as such and on all acculturated art.

Albino Braz (1893-1950)
Decurso [*Speech*], n.d.
Pencil on paper, 12⅜ x 8¼"
Braz began drawing after
he was institutionalized near
Sao Paolo, Brazil. His physi-
cian, Osorio Cesar, was close
to the artistic avant garde
and encouraged Braz's work.

Outsiders are also scavengers. The most important of these artists—
Wölfli, Darger, Ramirez—used collage in complex ways and developed
styles that somehow refracted the currents of mainstream visual culture
that surrounded them. Looking at Wölfli's art, with its snatches of music
posters, postcards, and advertisements, often seems like viewing Swiss-
German culture of the time, especially its kitsch and sentimentality,
through a distorting glass. In the case of Darger, the adoption of a cartoon
style is total, complete, and fully comprehended. For him, the reductive
contours of the cartoon are the only visual style appropriate to the apoca-
lyptic events he depicts, to their combination of innocence and depreda-
tion, control and catastrophe. Even autistic artists are borrowers, of a sort,
for as suggested above, the world presents itself to them first and foremost
as models to be visually interpreted and often incessantly recapitulated.
Sources for the art of Donald Mitchell, for example, include photographs
of cactuses and illustrations of acrobats, which he transforms beyond

recognition but with complete consistency. The so-called outsider is often nearer to us than we wish to acknowledge, and at the same time farther away than we choose to admit.

Dubuffet perhaps did not heed well his own nature as an artist. His insistence on an absolute division between insiders and outsiders has been taken up by many anticultural theorists, from philosopher Georges Bataille to critics Michel Thévoz and Roger Cardinal. Yet there are others, especially artists, who have contended that there are no outsiders; that all artists are one under the skin. Regardless of how remote they are from each other in situation, psychology, and historical period, their deeper affinities make them all contemporaries. At the same time, certain social, economic, and art-world trends have contributed to erasing at least the practical distinctions between insiders and outsiders, and even made the notion of self-tutored art nearly irrelevant.

Has outsider art come completely inside? If so, what does that mean for contemporary ideas about what art is and does, especially if Western avant-garde art has depended so heavily for its impetus and even its formal languages on what it defined as "outside"? I do not believe outsider and self-taught art can ever be comfortably folded into our historicized (so-and-so begat so-and-so) narratives about art, nor will time naturalize all their anomalous forms, that is, make them accessible or meaningful the way Cubist works, for example, now seem "normal" and Picasso's distortions no longer shock. At the same time, it seems clear that the broad acceptance of outsider art signals the end of our history-obsessed view of art, a view that spawned the idea of the avant-garde and first legitimized the outsider. The whole complex of ideas involving progress in art and consciousness now belongs to what critic Robert Hughes referred to as "the future that was."[41] By the same token, it seems to me that other explanatory narratives, especially post-colonial, have their limits, in spite of their success at rescuing art from categories of "naive," "primitive," and even "outsider." Insofar as they stubbornly retain an "otherness," outsider and self-taught art does have

a distinct role to play in the art of our time. That role is to summon us back, like the tolling of a bell, to the existential roots of art making, where apprehensions of being are transmuted into form.

Insiders as Outsiders as Insiders

First things first: Are outsiders and insiders really different? By the mid-1950s, Western artists had ransacked virtually every alternative or "primitive" visual source in support of various avant-garde positions. From the early modern period onward, each subsequent generation of artists felt more oppressed by the artistic past, more committed to making a break with it, and more troubled by the world around them. American Abstract Expressionists embraced Native-American art, and Latin Americans, following the lead of artists such as the Uruguayan Joaquín Torres García (1874–1949) and the Mexican muralist Diego Rivera (1886–1957), looked to the forms of ancient Central and South America. In general, these artists sought the common ground of art in what they regarded as mythic or archetypal imagery, that is, collectively resonant forms, springing supposedly from the human unconscious, which gave consistent expression to fundamental understandings of the universe. A deeper affinity was suggested by Barnett Newman (1905–1970), regarded as one of the pioneers of so-called Minimalist art. Newman believed that primitive artists—and by extension, we can suppose, untutored and outsider artists—shared with contemporary artists a solipsistic, spiritual urge to make sculpture and other objects as a response to the primal confrontation with natural forces indifferent to human will. For Newman, creativity existed prior to any imagery or myths, prior even to the urge to communicate or acknowledge others. Instead, creativity acknowledged first and foremost the otherness of existence.[42] Above all, the art impulse was utterly nonutilitarian and, hence, free.

This position, radical for its time, appears similar to the one taken by current theorists such as Thévoz, and it eschews the disquieting Western penchant for giving the seal of approval to certain cultures as "art-making"

or to specific imagery as "aesthetic," although Newman and other artists clearly had their favorites. Newman leaned toward the idea that the essence of art was abstract, that it was not fundamentally concerned with making pictures or forms of anything, but he offered no orthodoxy of abstraction. Other Minimalists such as sculptor Donald Judd (1928–1994) and painter Ad Reinhardt (1913–1967), were even more rigorous, not to say dogmatic. They were looking for specific instances of the impulse to form, embodied in works consistently attentive to their own logic and materials. "Specific objects" Judd called them. In their work, these artists sought to resist interpretation, especially analogies and metaphors, and force viewers to turn inward to their own immediate experience of a thing. Yet in stripping away so much from art (indeed, its entire symbolic language), in banishing self-expression, and in seeming to reduce the variety of possible forms, Minimalists actually furthered a broad trend inaugurated by Surrealism toward the acceptance of unclassifiable works of art, sui generis productions whose paradoxes are front and center and whose impact is beyond explication.

H. C. Westermann
Untitled, 1957
Mixed media, 8½ x 12 x 9¼"
Although the constructions of artists such as Westermann and Joseph Cornell (1903–1972) are often linked with various art movements, they stand stubbornly outside them.

Yayoi Kusama
Dustpan, 1965
Mixed media, 8 x 12 x 11½"
Inside moving outside:
Novelist and artist Kusama,
a provocative figure
in the 1960s art scene,
suffered frequent bouts
of mental illness and
often used hospitalization
as a kind of retreat.

On the deepest level, these works could not be anything but self-taught. Created by insiders, they nevertheless appeared to be without precedent or place. In some sense, they remain outside all categories of description. The satiric and surreal constructions of H. C. Westermann (1922–1981), the ominous wall constructions of Lee Bontecou (b. 1931), the dot-obsessed work of Yayoi Kusama (b. 1929), and the sculpture and performances of Joseph Beuys may have been accepted by the mainstream, but they still seem scarcely explicable and, like outsider art, mock the genteel spaces of their display. Beuys's art arose directly out of his traumatic experiences in World War II and evolved toward shamanistic and ritual practices. Kusama suffered from mental illness, and her work veered toward and away from the center of avant-garde activity during the 1960s and 1970s.

The deeper affinity of contemporary art with outsider art lies in the idea of a *conceptual* art. We think of Conceptual art, such as the *Proposition Player* of Matthew Ritchie (b. 1964)—an "omnivorous visualization system," and the elaborate Cremaster cycle of Matthew Barney (b. 1967) as art

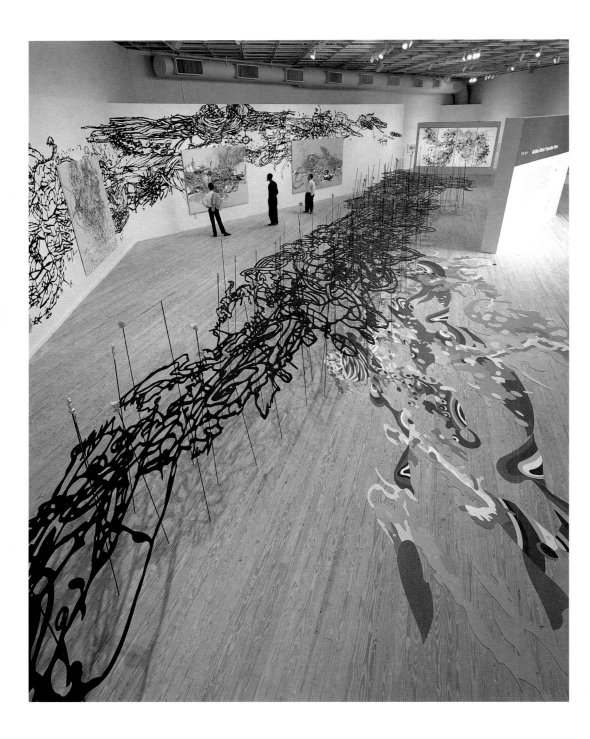

created according to a program or scheme known only to the artist and not, perhaps, directly intelligible to any audience. That is to say, it is an allegory. So Barney provides elaborate explanatory documentation to the Cremaster cycle's mélange of video, environments, Vaseline sculpture, and photographs, just as Wölfli and Josef Heinrich Grebing "explained" their systematic preoccupations. In other words, both contemporary and outsider art have significant nonvisual components that force us to think and imagine beyond what we see. The crucial difference may be that the explanations offered by outsiders can be understood only within the context of their systems and dovetail only at tantalizing moments with a wider, commonly shared frame of reference. Their systems are like snakes swallowing their tails. Barney's glosses, on the other hand, unrewarding as they might be, in some sense open out onto the contemporary and familiar milieu of art and popular culture. I would add that allegory may be the least satisfying aspect of outsider art and the most likely to lead down interpretive blind alleys.

These artists presage a new time of orphaned, unplaceable art, a time when the intimidating, hermetic privacy of outsider art and the deviations of autodidacts take their place among the fragmentary, self-sanctioning productions of artists everywhere. Call it pluralism or the end of art history as we know it, the paths from the outside in are many.

So, too, are the paths from inside out, and the pursuit of spiritual enlightenment can widen them to a highway. Many modern and contemporary artists have taken the highway to the outside in search of self-transcendence. The North Carolina artist Reverend McKendree Robbins Long (1888–1975) studied painting in Europe after the turn of the last century and continued to paint after he took up his Presbyterian ministry. In fact, he became well known as a minister-artist and did hundreds of paintings concerning a fantastic "woman in red," whose identity he never revealed. In the 1960s, Long's work took a profoundly allegorical turn. He began to produce paintings at breakneck speed that detailed his vision of the Apocalypse, a vision in which, among other things, contemporary figures such as Salvador Dalí are cast into a lake of fire.

OPPOSITE: **Matthew Ritchie** *Proposition Player,* 2003 Mixed-media installation Like many outsiders, Ritchie proposes a vast scheme of representation incorporating an array of scientific insights, from game theory to neuroscience to linguistics.

Rev. McKendree Robbins Long
*The Damned Are Cast
into the Lake of Fire and
Brimstone*, 1968
Oil on canvas, 52 x 40"
Long's mystical vision left
both his conventional training
and the art world behind;
the damned here include
Salvador Dalí.

Piling the canvases up as fast as he painted them, Long often gave them away
to anyone interested and continued in this vein until just before his death.

The 1985 exhibition "The Spiritual in Art: Abstract Painting 1890–1985"
unveiled a number of artists whose practices sprang from their spiritual
pursuits, and although this was not its purpose, the exhibition redrew the
boundaries of inside and outside.[43] One of the most important examples is
Alfred Jensen (1903–1981). A conventionally exhibiting artist and acquain-
tance of Mark Rothko, among others, Jensen was also absorbed in studying
the color theory of Goethe, Pythagorean geometry, electromagnetism, and
the Mayan calendar and pantheon of gods. This knowledge he attempted
to synthesize in a series of highly schematic paintings combining geometric
abstraction with number and color symbolism. The work bears the obses-
sional repetitiveness, hermeticism, and prophetic insistence of outsider art,
as well as the totalizing tendency to assimilate the most disparate elements

of knowledge and experience into an elaborate system, much like the healing machines of Emery Blagdon. In terms of the art world, Jensen's work simply leapt out of any contemporary context or discussion. Jensen has been called a visionary, a mystagogue, and a modernist. But in spirit his work resembles more the calendars and color charts of the outsider Grebing than it does, for instance, the chromatic geometries created by Kenneth Noland (b. 1924), to which his paintings have sometimes been compared.

Both Long and Jensen operated within the horizons of the art world and participated to a greater or lesser degree in its marketplace. Although this chapter has been defining "outsider" largely in terms of a distance from the art world, this is at best a misleading criterion. If insiders can move to the outside, outsiders and self-taught artists can occupy ambiguous relationships to the commercial art world, neither quite in nor out. Albert Louden (b. 1943) is a self-taught British artist whose imagery became so idiosyncratic that it has had difficulty finding a place within the mainstream art

Alfred Jensen
My Oneness, a Universe of Colours, 1957
Oil on canvas, 26 x 22"
One of the images Jensen used to express his vision of a unified experience of self, world, and spirit was the tantric mandala, which he painted with thick, vibrant color to give it a worldly materiality.

world, which initially adopted his work. Lonnie Holley (b. 1950), a self-taught African American artist, is outspoken about the place his sculptural assemblages occupy in relation to his community, the work of other African-American artists, and the mainstream. Clearly he is not a classic outsider, but attempts to situate him in Africa-based traditions are useful only to a point. Holley has developed an ambitious formal and cultural vocabulary that far exceeds the limits of folk vernacular and puts him closer to the assemblage artists of the 1960s and 1970s. To take another example, Michael Nedjar (b. 1947) is a French filmmaker and artist whose only connection to outsider art appears to be the rawness of his imagery, which has been influenced by the *Collection de l'Art Brut*. Yet he is regularly exhibited as an outsider. Nedjar's work raises the question of whether the designation of outsider art can depend in any way on intrinsic formal qualities.

No Such Place as Outside

When it comes to buying and selling, clearly there is no such place as outside. Tabling the question that opened this book, of whether there is a specifiable difference between outsiders and insiders, there is no doubt the art products of outsiders have found their way to the center of the marketplace, as have the artists themselves, on occasion. Jon Serl and Howard Finster, to name two, appeared on national television, and Finster's work was included in the 1984 Venice Biennale. Work by artists from Gugging has also been shown at Venice. Outsiders and self-taught artists have been the subjects of a host of documentaries and, in 1989, British writer and editor John Maizels established a glossy, international magazine devoted exclusively to outsider and self-taught art, *Raw Vision*. Darger's art even inspired a book-length poem by John Ashbery.[44] In 2003, Christie's held its first auction of outsider art, from the extensive collection of New Yorker Robert Greenberg. The sale, which included works by many of the leading artists of *art brut*, including Wölfli, Carlo Zinelli, Ramirez, Darger, and Finster, did not establish the stratospheric prices some expected, but it did confirm,

at least temporarily, the viability of an auction market for this work. Perhaps even more significant has been the growing number of exhibitions, some at major museums, that juxtapose work by insiders and outsiders.

Until recently, outsider and self-taught works were ghettoized into their own exhibitions and even their own museums. There are museums devoted to this art around the world; in Austria, Australia, Croatia, France, Great Britain, Russia, Serbia, Switzerland, and the United States. More are being proposed even now. There have even been exhibitions of outsider art in Morocco and Japan. Because most of these collections and museums contain work made according to diverse intentions and in different circumstances, their group exhibitions have the unintended consequence of actually adding to confusion about the nature of the objects they show. But several galleries and some major museums have attempted to bring outsider art into a direct visual dialogue with contemporary and historical art. They follow in the pioneering footsteps of the artist Alfonso Ossorio (1916–1990), who, as early as 1952, was hanging outsider works next to Pollocks and DeKoonings in his house. It is ironic that precisely at the moment when outsider art is being granted a genre status by the art establishment, that status is being undermined by other, more forward-looking elements of the same establishment. The following discussion of a few brief examples indicates the growing accommodation of the art world to outsider and self-taught work.

Because of the enthusiasm of Otto Kallir for the folk painter Grandma Moses, the gallery he founded in New York to sell German Expressionist art, Galerie St. Etienne, also presents work by outsider and selected self-taught artists, including Darger and the Gugging artists. Over the last decade, the gallery has argued that this extreme work, although it lacks ties to any art movement, should be seen as Expressionist in nature. Taking a different approach, K.S. Art, another New York gallery, routinely juxtaposes self-taught and outsider work with that of contemporary insiders, including Elizabeth Murray and Thomas Nozkowski. Cavin-Morris Gallery asserts different affiliations with outsider art, especially tribal and ethnic art via the connec-

tion of spiritual expression. The Ricco/Maresca Gallery is emblematic of the broad evolution of outsider presentation. Begun in the 1980s as a locale for folk art, it soon incorporated more challenging work, including the self-taught William Hawkins and outsiders Judith Scott and Laura Craig McNellis (b. 1957). More recently, the gallery has juxtaposed these artists with such contemporary insiders as photographers Joel-Peter Witkin and Gerald Slota, artists at the transgressive edge of their disciplines.

At many museums, it has become routine to include self-taught and outsider artists in group exhibitions dominated by insider art. New York's New Museum for Contemporary Art has been presenting outsider art at least since 1983. This practice signals a movement away from the historical and biographical narratives that have been museums' stock-in-trade and toward thematic presentations spurred by contemporary art. It also indicates that museums may be bringing a new level of discrimination to this work, making distinctions based on the content and situation of the art rather than letting a collection of unrelated works rest uncomfortably with each other in a room labeled "contemporary folk art." One of the most compelling curatorial assertions of kinship occurred in 1987 in an exhibition organized by the University of Mainz, Germany, and it did not include outsider art at all. "Von Chaos und Ordnung der Seele" (Of the Soul's Chaos and Order) presented works by leading contemporary artists, including Cindy Sherman, Beuys, David Salle, and Francesco Clemente in the setting of the university's psychiatric clinic. Here was a turning of the tables that Hans Prinzhorn would have appreciated. In spite of the absence of outsiders, the curators marked out a common ground for insider artists and the institutionalized. The ground was that of art—art not of cultural communication but of individual testimony about struggles within the psyche. Also included in the exhibition were works by German artist Arnulf Rainer (b. 1929), who has created collaborative drawings with artists from the Gugging Clinic.

In 1992, the Los Angeles County Museum of Art (LACMA) mounted a pivotal exhibition that juxtaposed modern and contemporary insiders with

outsiders in an attempt to show the stylistic and cultural impact of extreme art. "Parallel Visions" amounted to a latter-day version of the Museum of Modern Art's 1984 exhibition "'Primitivism' in Twentieth Century Art." LACMA presented a host of examples of artists influenced in some way by their contact with outsider art, including Gregory Amenoff, a collector of Martin Ramirez's drawings; Chicago artists Roger Brown (b. 1941), and Jim Nutt (b. 1938), who had extensive contact with the outsider Joseph Yoakum; and French installation artist Christian Boltanski (b. 1944). Since then, many insider artists have emerged whose work bears striking traces of outsider practices. To take two examples, James Siena (b. 1957) employs the obsessive linear drawing and repeated patterning that appears in so many outsider works, including those of Ramirez. There is a systematic,

James Siena
Black Interface, 2003
Ballpoint pen on paper, 6 x 4"
Siena's patterning owes less to recent art movements such as Neo-Geo and more to the obsessionally repetitive motifs of outsider art.

almost machinelike quality to his labyrinths and radiating lines that suggests knowledge of systems structured beyond individual human will or intention. Decades ago, Jeff Way (b. 1942) was an accomplished "process" painter, an abstractionist who used experiments with materials, time, and chance to generate abstract paintings. But his contact with outsider and self-taught work has had a profound impact on the evolution of his style. Much of his current work involves the systematic distortion and transformation of photographic and print portraits in an attempt to recover the psychic or archaic energy banished from conventionalized imagery.

Neither Prinzhorn nor Dubuffet could have predicted that the art forms they thought challenged the very definitions of Western art, not to mention mainstream taste, would become part of the wallpaper of contemporary visual culture. Yet faux-primitive and outsiderish figuration now appears everywhere in the work of a host of derivative artists and even interior

Jeff Way
Grid Heads III, 2004
Collage and oil pastel
on paper, 30 x 22"
Influenced by self-taught
artists in his native Ohio,
Way melds expressionistic
distortions with a post-
Pop-art interest in process-
driven techniques.

designers. In the cases of Nedjar and Jean-Michel Basquiat, there are clear and compelling reasons for the artists to have adopted crude, simplified idioms; we can say that the end justified the means. Nevertheless, critics and collectors alike are increasingly skeptical of claims made for works based primarily on their putative outsider status, or the raw crudeness or childlike simplicity of their imagery.

Two other developments have further eroded the validity of outsider and self-taught categories. The simultaneous rise of the mass media and art education as a form of career preparation has made the notion of the isolated self-taught artist untouched by culture an anachronism. The highly localized rural worlds that initially nurtured the imagery of such self-taught luminaries as Bill Traylor and Finster scarcely exist any longer. We have already suggested that the notion of a pure, unacculturated art, even among autistic artists, is a myth and that in some sense all artists are self-taught. Indeed, many idiosyncratic artists model their ambitions and "careers" on those of an art world that is ever more visible and pervasive, even as they draw heavily on the visual material of popular culture. Late in his life, Finster, for example, recruited relatives to produce his work in an assembly-line fashion, much like contemporary artists Clemente and Jeff Koons. Thornton Dial, Sr. (b. 1928), one of the best-known self-taught artists, has enjoyed enormous success. His work has been acquired by some of the leading collectors of modern art. With such recognition, Dial's own artistic self-consciousness has grown, and he has increased his range of materials and themes.

Within and beyond institutional settings, the expanding armamentarium of drugs to manage psychiatric conditions appears to have diminished the output and intensity of artistic production. As a result, some theorists insist that the time of *art brut* is long since over. Given the complex circumstances of creativity, at least as outlined in an earlier chapter, any alteration of the significant conditions of inner experience could make the form-giving impulse disappear. Art-making requires reservoirs of energy and concentration, as well as an inner tension and irresolution that powerful therapies

can devitalize or suppress. Nevertheless, the impulse to form is so bound up with conditions such as schizophrenia and autism that art-making—*art brut,* true outsider art—will not disappear until the sources of these conditions, not merely their unacceptable behavioral aspects, are eradicated.

Beyond the Grass Ceiling

There will always be people who, without formal training, often in dire psychic or physical straits, and with no hope of recognition or reward, give visual form to their inner apprehensions. We call these people artists, and it scarcely matters what other labels we affix. At the same time, it is crucial to recall that the meaning of any work of art does not inhere within its forms. It is made by audiences in an endlessly shifting transaction with the object. The making of meaning and the conferring of value are bound up with our personal histories and the culture we inhabit, and no work, whatever its origin, once it is engaged, can remain "outside." In naming artists as outsiders or naive or primitive or self-taught, even in an effort to champion the cause of their wider appreciation, we create a "grass ceiling." That is, we reinforce dubious categories such as "primitive"—hence the reference to grass ceiling—that qualify the status of the art while saying little about its actual content and circumstances. Indeed, the categorizing almost inevitably misleads. As Randall Morris has put it, it is like cutting off every limb that doesn't fit in the coffin. We return to the question of whether the categories that define this book ought to be left behind. Certainly from the perspective of dealers and collectors, the answer should be "yes," if for no other reason than the marketplace: Under these rubrics, the work will never realize the highest commercial value. It will always be the representative of a type, even if the value of the type ("outsider art") increases. At any time in the art world, there is room only for a few sanctified representatives of any type.

On the other hand, the grass ceiling also provides a comfortable awning for work whose primary or only interest may be the circumstances of its creation or transmission. The work need never be subjected to broader and

more careful scrutiny that comprehends the full range of artistic produc-
tion and the ways in which art becomes meaningful to audiences. Such
scrutiny might reduce the value of works that suddenly appear as little
more than clumsy or limited versions of insider work.

There may be a more productive way of thinking about outsider art that
avoids reductive labels but acknowledges some of its conditions and inten-
tions. Such a scheme would not revert to the outworn opposition between
"pure" and "cultured" art, "naive" and "sophisticated," "raw" and "cooked."
The scheme relates the work along a continuum of communicative action,
cultural mediation, and temporal engagement.

	CONVENTIONAL	ECCENTRIC	AUTISTIC, SCHIZOPHRENIC
CULTURE	DETERMINED	⟷	UNMEDIATED
HISTORY	TIMEBOUND	⟷	ASYNCHRONIC
AUDIENCE	PUBLIC	⟷	PRIVATE/NONE

Admittedly, this is overly schematic, perhaps just another one of those
coffins that neccessitates lopping off too many limbs to get the body in.
It doesn't do justice to the complicated communicative nature of work at
either end of the spectrum, but it has the virtue of making all work part
of one world. At one end of the spectrum are works produced for and
exhausted by the audiences of a particular time. Placement is subjective,
of course. Some people would label Warhol's art the most conventional
of all. At the other end are works that on some level may always remain
unknown, unplumbed, and radically incomplete. We have called the time
sense they embody "asynchronic" rather than timeless in order to indicate
that the makers often treat time and history selectively or propose other
frames. This scheme also avoids the implication that one location on the
grid is "better" than another, as anticulturalists would insist. Rather, works
at different coordinates offer different experiences under different condi-
tions. The category of "self-taught" drops away completely, or is perhaps

folded in under the heading of "culture," which is another way of designating that which an artist inherits.

The most important fact about our chart is that the ends of the spectrum are related. They are fundamentally affiliated through the acts of conceiving and making an imaginative object, and that affiliation has implications for the way we look at all art.

It is impossible to approach outsider and most self-taught art via the accepted canons of art history, to situate it within familiar movements and influences. Which is not to say that we cannot draw new genealogies. That has been done for certain African-American artists who had long been regarded as traditionless, naive, and idiosyncratic. At the same time, however, these works also tell us that situating any work of art in history and theory is problematic. In doing so, we shift emphasis away from existential experience of the thing toward a "reading" of it, a set of interpretations that can, over time, displace the work or obscure it. The opposite of an orphaned work is one with too many relatives, so many that we cannot see it except in familial terms. For the best-known artists, it can begin to seem as if history itself created their art. Works by artists from Mondrian and Matisse to Blinky Palermo (b. 1943) all become chapters in a vast textbook of the evolution of artistic consciousness or, in postmodern terms, fields of play for impersonal cultural signifiers. This sense of impersonality grows with every re-presentation of a work of art, every digital and printed image. In this all-encompassing system of secondhand experience, the works become icons, canceling our direct perception of them as performances, foreclosing all but the narrowest visual participation. We lose, for instance, the sense of urgency and finicky obsessiveness of Picasso's so-called Analytic Cubism, the contradictory tactile qualities of Mondrian's grids, and the strange loquacity of Ad Reinhardt's black paintings. Outsider art—those works that resolutely resist such invisibility by confounding our conceptual categories—can act as a spur to aesthetic conscience. "Look again," they seem to say. "Look directly and assume nothing."

Artists do not make things in order to fit academic categories or to fill postage-stamp slots in art-history books, even though history may be on their minds. They do it because, fundamentally, it feels better to do it than to do anything else, and not to do it is untenable. They don't know when to stop. And they make so-called alternative universes because every act of imagination presupposes an "alternative universe." But such alternatives are never divorced from the world because they are created in the world and manifested in it, to us. Often it takes time for the deeper affiliations to reveal themselves, or for us to forge them, for us to see how even the most hermetic objects mediate between one mind's experience of reality and another's. As Charles Russell put it, "They [outsider artists] reveal the drama of being in the world, of making meaning, of conceptualizing and framing a world that is recognized—in all its strangeness—as our very own."[45]

Perley M. Wentworth
(active ca. 1950s)
Untitled (Rays of White on the Cross), ca. 1951
Pastel, graphite, charcoal, and mixed media on paper, 17 x 22"
The more visionary the experience, the more precise its rendering: Little is known of Wentworth; his name is a cipher. But he wrote the date, time, and circumstances of his vision on the drawing, as if to confirm its objective reality.

ENDNOTES

1. Peter Schjeldahl, *Columns & Catalogues* (Great Barrington, Mass.: The Figures, 1994), p. 244.
2. Frank Maresca and Roger Ricco, with Lyle Rexer, *American Self-Taught: Paintings and Drawings by Outsider Artists* (New York: Knopf, 1993).
3. Roger Cardinal, *Outsider Art* (New York: Praeger, 1972), p. 52.
4. Robert Farris Thompson, *Flash of the Spirit: African and Afro-American Art and Philosophy* (New York: Random House, 1983).
5. Robert Goldwater and Marco Treves, eds., *Artists on Art, from the XIV to the XX Century* (New York: Pantheon, 1958), p. 298.
6. Lucy Lippard, ed., *Dadas on Art* (Engelwood Cliffs, N.J.: Prentice Hall, 1971), p. 123.
7. Quoted in John Maizels, *Raw Creation: Outsider Art and Beyond* (London: Phaidon: 1996), p. 33.
8. Quoted in ibid., p. 15.
9. Hal Foster, "No Man's Land: On the Modernist Reception of the Art of the Insane," in Catherine de Zegher, ed., *The Prinzhorn Collection: Traces upon the Wunderblock* (New York: The Drawing Center, 2000), pp. 9–22.
10. Alfred Barr, Jr., *Masters of Popular Painting* (New York: Museum of Modern Art, 1938), p. 9.
11. Arthur Danto, "The Artworld and its Outsiders," in *Self-Taught Artists of the 20th Century: An American Anthology* (San Francisco: Chronicle Books, 1998), p. 22.
12. Quoted in Maizels, *Raw Creation,* p. 35.
13. Richard Gordon, "Postcards from the Edge," *The Connection,* radio broadcast, WBUR, Boston, May 7, 2003.
14. Michel Thévoz, *Art Brut* (Geneva: Skira, 1995), p. 155.
15. Robert Greenberg, *Self-Taught Outsider Art Brut: Masterpieces from the Robert M. Greenberg Collection* (New York: Ricco Maresca Gallery, 1999), p. 10.
16. Charles Baudelaire, "Delacroix" in *The Mirror of Art,* trans. Jonathan Mayne (Garden City, N.Y.: Anchor, 1956), p. 218.
17. Norbert Elias, *Power and Civility* (New York: Pantheon, 1982).
18. Quoted in M. H. Abrams, *Natural Supernaturalism* (New York: Norton, 1971), p. 417.
19. Dave Hickey, *Enter the Dragon* (Los Angeles: Art Issues Press, 1995), p. 18.
20. Plato, *Dialogues* (New York: Random House, 1920), p. 534.
21. Michael Edwards, "Art, Therapy, and Romanticism," in *Pictures at an Exhibition: Selected Essays on Art and Art Therapy* (London: Routledge, 1989), p. 80.
22. Colin Rhodes, *Outsider Art: Spontaneous Alternatives* (London: Thames & Hudson, 2000), p. 53.
23. Francis V. O'Connor, *Jackson Pollock* (New York: Museum of Modern Art, 1967), p. 73.
24. Peter Fuller, "Mother and Child in Henry Moore and Winnicott," in Gilroy and Dalley, *Pictures,* p. 18.
25. Thévoz, *Art Brut,* p. 123.
26. Mary Barnes and Joseph Berke, *Mary Barnes: Two Accounts of a Journey through Madness* (New York: Harcourt Brace, 1972), p. 147.
27. Foster, "No Man's Land," p. 14.
28. Anton Ehrenzweig, *The Hidden Order of Art: A Study in the Psychology of Artistic Imagination* (Berkeley: University of California Press, 1967).
29. Quoted in Oliver Sacks, *An Anthropologist on Mars: Seven Paradoxical Tales* (New York: Knopf, 1995), p. 59.
30. Ibid., p. 242.
31. Quoted in Thévoz, *Art Brut,* p. 187.
32. Allen S. Weiss, "Prinzhorn's Heterotopia" in Catherine de Zegher, ed., *The Prinzhorn Collection;* p. 55.
33. Judy Higdon, "Trees is Soul People to Me," interview with Bessie Harvey, in Simon Carr, Sam Farber, Betsey Wells Farber, Allen S. Weiss, eds., *Portraits from the Outside: Figurative Expression in Outsider Art* (New York: Groegfeax, 1990), p. 69.
34. Quoted in Lippard, *Dadas on Art,* pp. 103–4.
35. Quoted in Gary Schwindler, "You want to see Somethin' Pretty?" in Roger Ricco and Frank Maresca, *William Hawkins Paintings* (New York: Knopf, 1997) p. vii.
36. John M. MacGregor, Leon Borensztein, and Irene W. Brydon, *Metamorphosis: The Fiber Art of Judith Scott* (Oakland, Calif.: Creative Growth Art Center, 1999), pp. 70–97.
37. Quoted in Lyle Rexer, *Photography's Antiquarian Avant-Garde: The New Wave in Old Processes,* (New York: Abrams, 2002), p. 37.
38. Friedrich Hölderlin, "Mnemosyne," quoted in Richard Unger, *Hölderlin's Major Poetry* (Bloomington: Indiana University Press, 1975), p. 218.
39. Leo Navratil, *August Walla: Sein Leben und Seine Kunst* (Nordlingen, Greno Verlag, 1988), p. 158.
40. Lisa Jardine, *Worldly Goods* (London: Macmillan, 1996), pp. 379–83.
41. Robert Hughes, *The Shock of the New* (New York: Knopf, 1980), p. 365.
42. Barnett Newman, "The First Man Was an Artist," *The Tiger's Eye* (October 1947), pp. 47–50.
43. Maurice Tuchman, ed., *The Spiritual in Art: Abstract Painting 1890–1985* (New York: Los Angeles County Museum of Art/Abbeville Press, 1986).
44. John Ashbery, *Girls on the Run: A Poem* (New York: Farrar, Straus and Giroux, 1999).
45. Charles Russell, "Finding a Place for Self-Taught Art," in *Self-Taught Art: The Culture and Aesthetics of American Vernacular Art* (Jackson: University Press of Mississippi, 2001), p. 23.

BIBLIOGRAPHY

In the last decade, the volume of published material on outsider art has grown exponentially, even as full exploration of this art has had to take into account many works outside the field. The challenge is daunting. The following bibliography is a selective list of important, generally accessible works.

Anderson, Brooke Davis. *Darger: The Henry Darger Collection at the American Folk Art Museum*. New York: Harry N. Abrams, 2001.

Arnett, Willam, Paul Arnett, et al. *Souls Grown Deep: African American Vernacular Art of the South*, 2 vols. Atlanta, Ga.: Tinwood Books, 2000–2001.

Beardsley, John. *Gardens of Revelation*. New York: Abbeville Press, 1995.

Brand-Claussen, Bettina, Inge Jádi, and Caroline Douglas. *Beyond Reason: Art and Psychosis*. Berkeley: University of California Press, 1996.

Cardinal, Roger. *Outsider Art*, New York: Praeger Books, 1972.

Dubuffet, Jean. *Asphyxiating Culture and Other Writings*. New York: Four Walls Eight Windows Press, 1988.

Goldwater, Robert. *Primitivism in Modern Art* (expanded ed.). Cambridge: Belknap Press of Harvard University Press, 1986.

Hall, Michael, and Eugene Metcalf, Jr., eds. *The Artist Outsider*. Washington, D.C.: Smithsonian Institution Press, 1994.

Helfenstein, Joseph, and Roman Kurzmeyer, *Deep Blues, Bill Traylor 1854-1949*. New Haven: Yale University Press, 1999.

Hernandez, Jo Farb, John Beardsley, and Roger Cardinal. *A. G. Rizzoli, Architect of Magnificent Visions*. New York: San Diego Museum of Art and Harry N. Abrams, 1997.

Julius, Anthony. *Transgressions: The Offenses of Art*. Chicago: University of Chicago Press, 2003.

Klein, Rachel, and Gayleen Aiken, *Moonlight and Music, The Enchanted World of Gayleen Aiken*. New York: Harry N. Abrams, 1997.

MacGregor, John. *The Discovery of the Art of the Insane*. Princeton: Princeton University Press, 1989.

MacGregor, John. *Metamorphosis, The Fiber Art of Judith Scott*. Oakland, Calif.: Creative Growth Art Center, 1999.

MacGregor, John *Henry Darger: In the Realms of the Unreal*. New York: Delano Greenidge Editions, 2002.

Maizels, John. *Raw Creation: Outsider Art and Beyond*. London: Phaidon, 2001.

Maizels, John. *Raw Vision Outsider Art Sourcebook*. Radlett, England: Raw Vision, 2002.

Maresca, Frank, and Roger Ricco. *William Hawkins Paintings*. New York: Alfred A. Knopf, 1993.

Navratil, Leo. *August Walla, Sein Leben und Seine Kunst*. Nordlingen, Germany: Greno Verlang, 1988.

Park, Clara Claiborne. *Exiting Nirvana*. Boston: Little, Brown and Company, 2001.

Rexer, Lyle, Frank Maresca, and Roger Ricco. *American Self-Taught: Paintings and Drawings by Outsider Artists*. New York: Alfred A. Knopf, 1993.

Rexer, Lyle. *Jonathan Lerman, Drawings of an Artist with Autism*. New York: George Braziller, 2002.

Peiry, Lucien. *Art Brut, the Origins of Outsider Art*. Paris: Flammarion, 2001.

Rhodes, Colin. *Outsider Art, Spontaneous Alternatives*. New York: Thames and Hudson, 2000.

Sacks, Oliver. *An Anthropologist on Mars*. New York: Alfred A. Knopf, 1995.

Shaw, Jim, ed. *Thrift Store Paintings*. Hollywood, Calif.: Heavy Industries Press, 1990.

Spoerri, Elka, and Daniel Bauman. *The Art of Adolf Wölfli, St. Adolf-Giant Creation*. Princeton: American Folk Art Museum and Princeton University Press, 2003.

Thévoz, Michel. *Art Brut*. London and New York: Skira, 1995.

Tuchman, Maurice, et al. *The Spiritual in Art, Abstract Painting 1890-1985*. New York: Los Angeles County Museum of Art and Abbeville Press, 1986.

Tuchman, Maurice, and Carol S. Eliel. *Parallel Visions: Modern Artists and Outsider Art*. Princeton: Los Angeles County Museum of Art and Princeton University Press, 1992.

Turner, John. *Howard Finster, Man of Visions*. New York: Alfred A. Knopf, 1989.

Turner, John, and Deborah Klotchko. *Create and Be Recognized: Photography On the Edge*. San Francisco: Chronicle Books, 2004.

Zolberg, Vera, and Joni Maya Cherbo. *Outsider Art: Contesting Boundaries in Contemporary Culture*. Cambridge: Cambridge University Press, 1997.

CREDITS

Page 1: Courtesy K.S. Art, New York; Pages 2 & 90: Courtesy the author; Page 7: Courtesy Ricco/Maresca Gallery, New York; Page 8: Courtesy Aarne Anton; Page 9: Courtesy Jennifer Pinto Safian Collection; Page 12: Courtesy Larry Dumont Collection; Page 13: Courtesy Marvill Collection; Page 14: Courtesy the Mendelsohn Collection; Page 21: Courtesy Jennifer Pinto Safian Collection; Page 22: Courtesy Museum of Contemporary Art, Houston, Private Collection, Chicago; Page 24: Courtesy Salander-O'Reilly Galleries, New York, Private Collection; Page 25: Courtesy Private Collection; Page 26: Courtesy Janice and Mickey Cartin Collection; Page 27: Courtesy Ricco/Maresca Gallery, New York; Page 28: Courtesy Janice and Mickey Cartin Collection; Page 30: Courtesy Jaffee Family Collection; Page 33: Courtesy Janice and Mickey Cartin Collection; Page 34: Courtesy the Prinzhorn Collection, Heidelberg; Page 35: Courtesy Private Collection: Page 36: Courtesy Siri von Reis Collection; Page 37: Courtesy Briskin Family Collection; Page 38: Courtesy G.R.A.C.E., Hardwick, VT, Photograph by Michael Gray; Page 41: Courtesy Frank Maresca; Page 43: Courtesy K.S. Art, New York; Page 45: Courtesy Luise Ross Gallery, New York; Page 47: Courtesy Joel-Peter Witkin and Ricco/Maresca Gallery, New York; Page 52: Courtesy Don Christensen, Photograph by Jon Blum; Page 54: Courtesy Collection de l'Art Brut, Lausanne, Photograph by Claude Bornand; Page 55: Courtesy K.S. Art, New York; Page 56: Courtesy Robert M. Greenberg Collection; Page 59 (top): Courtesy Collection de l'Art Brut, Lausanne, Photograph by Claude Bornand; Page 59 (bottom): Courtesy Collection de l'Art Brut, Photograph by Claude Bornand; Page 60: Courtesy Andrew Edlin Gallery, New York; Page 61: Courtesy Luise Ross Gallery, New York; Page 62: Courtesy the Prinzhorn Collection, Heidelberg; Page 63: Courtesy Collection abcd, Paris; Page 64: Courtesy Collection abcd, Paris; Page 65: Courtesy K.S. Art, New York, Private Collection; Page 66: Courtesy Kerrigan Campbell Art + Projects, New York, Gallery and Atelier Herenplaats, Rotterdam; Page 67: Courtesy Margaret Bodell, Private Collection; Page 69: Courtesy G.R.A.C.E, Hardwick, VT, Photograph by Michael Gray; Page 71: Courtesy Ricco/Maresca Gallery; Page 73: Courtesy Judy Saslow Collection, Photograph courtesy Carl Hammer Gallery, Chicago; Page 75: Courtesy Cavin-Morris Gallery, New York Private Collection; Page 76: Courtesy Siri von Reis Collection; Page 77: Courtesy Paul and Dana Caan Collection, Photograph courtesy Creative Growth Art Center, Oakland; Page 78: Courtesy K.S. Art, New York; Page 80: Courtesy Collection abcd, Paris; Page 81: Courtesy Hayes Collection; Page 83: Courtesy K.S. Art, New York; Page 84: Courtesy Fleisher Ollman Gallery, Philadelphia, Photograph courtesy Phyllis Kind Gallery, New York, Private Collection; Page 85: Courtesy the author; Page 86: Courtesy Cavin-Morris Gallery, New York, David Kohler Collection; Page 87: Courtesy Ricco/Maresca Gallery, New York; Page 88: Courtesy Collection abcd, Paris; Page 89: Courtesy G.R.A.C.E., Hardwick, VT, Photograph by Michael Gray; Page 91: Courtesy K.S. Art, New York; Page 92: Private Collection; Page 93: Courtesy Robert M. Greenberg Collection; Page 95: Courtesy Robert M. Greenberg Collection, Photograph courtesy The Ames Gallery, Berkeley; Page 96: Courtesy Adolf Wölfli Foundation, Museum of Fine Arts, Bern, Photograph by Peter Lauri; Page 97: Courtesy Phyllis Kind Gallery, New York; Page 99: Courtesy Robert M. Greenberg Collection; Page 100: Courtesy Ricco/Maresca Gallery, New York; Page 101: Courtesy Robert M. Greenberg Collection; Page 103: Courtesy Carl Hammer Gallery, Chicago; Page 104: Courtesy Cavin-Morris Gallery, New York and Whitney Museum of American Art; Page 105: Courtesy Cheryl Rivers; Page 106: Courtesy the Prinzhorn Collection, Heidelberg; Page 107: Courtesy Cheryl Rivers; Page 108: Courtesy K.S. Art, New York; Page 109: Courtesy the Mendelsohn Collection; Page 112: Courtesy G.R.A.C.E., Hardwick, VT, Photograph by Michael Gray; Page 114: Courtesy Marion Harris, Connecticut and New York; Page 116: Courtesy Don Christensen, Photograph by Trace Rosel/ The Emery Blagdon Project; Page 118: Courtesy K.S. Art, New York; Page 120: Courtesy Cheryl Rivers; Page 122: Courtesy Robert M. Greenberg Collection; Page 124: Courtesy Ricco/Maresca Gallery, New York; Page 126: Courtesy the Prinzhorn Collection, Heidelberg; Page 128: Courtesy Ricco/Maresca Gallery, New York; Page 130: Courtesy the author; Page 132: Courtesy the Prinzhorn Collection, Heidelberg; Page 134: Courtesy Robert Provenzano; Page 136: Courtesy the author; Page 138: Courtesy Collection de l'Art Brut, Lausannem Photograph by Creative Growth Art Center, Oakland; Page 140: Courtesy Cavin-Morris Gallery; Page 142: Courtesy Norman Brosterman, Photograph by Zindman/Fremont; Page 144: Courtesy the author; Page 146: Courtesy Artists' House, Gugging Clinic, Klosterneuberg, Austria; Page 148: Courtesy Norman Brosterman, Photograph by Zindman/Fremont; Page 150: Courtesy Adolf Wölfli Foundation, Museum of Fine Arts, Bern, Photograph by Peter Lauri; Page 153: Courtesy Collection abcd, Paris; Page 156: Courtesy Janice and Mickey Cartin Collection; Page 157: Courtesy D'Amelio Terras Gallery, Private Collection; Page 158: Courtesy Contemporary Arts Museum/Houston, Photograph by Hester + Hardaway; Page 160: Courtesy Luise Ross Gallery, New York; Page 161: Courtesy Janice and Mickey Cartin Collection; Page 165: Courtesy the artist; Page 166: Courtesy the artist; Page 171: Courtesy Robert M. Greenberg Collection.

Page numbers in *italics* refer to illustrations.

WITHDRAWN